Books & Mortar

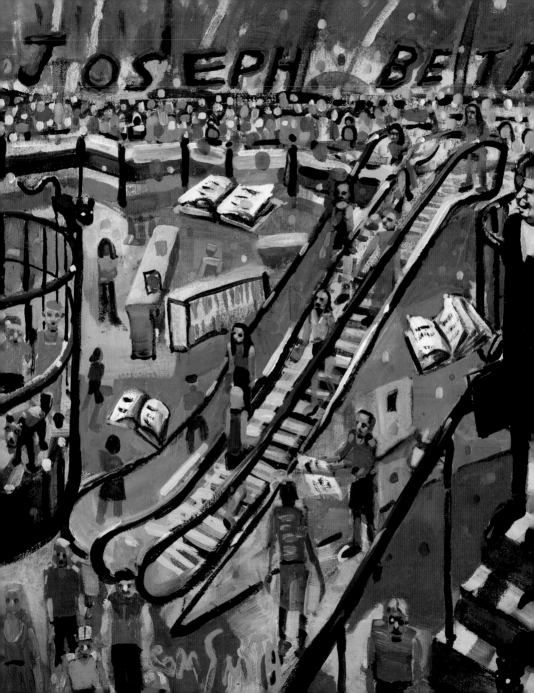

Books & Mortar

A CELEBRATION OF THE LOCAL BOOKSTORE

GIBBS M. SMITH

GIBBS SMITH
TO ENRICH AND INSPIRE HUMANKIND

Gibbs M. Smith, *Joseph Beth Booksellers,* 2010. Oil on linen, 16" × 20".

First Edition
22 21 20 19 18 5 4 3 2 1
Text © 2018 Gibbs Smith Publisher
Illustrations © 2018 Gibbs M. Smith
Published by
Gibbs Smith
P.O. Box 667
Layton, Utah 84041
1.800.835.4993 orders
www.gibbs-smith.com
Designed by Debbie Berne
Printed and bound in China

Gibbs Smith books are printed on
either recycled, 100% post-consumer
waste, FSC-certified papers or on paper
produced from sustainable PEFC-certified
forest/controlled wood source. Learn
more at www.pefc.org.

Library of Congress Cataloging-in-
Publication Data
Names: Smith, Gibbs M., author, artist.
Title: Books & mortar : a celebration of
the local bookshop / Gibbs M.
Smith
 ; Illustrations by Gibbs M. Smith.
Other titles: Books and mortar
Description: First edition. | Layton, Utah :
Gibbs Smith Publisher,
[2018]
Identifiers: LCCN 2018001266 | ISBN
9781423650430 (jacketless
hardcover)
Subjects: LCSH: Bookstores--Pictorial
works. | Booksellers and
 bookselling--Pictorial works. |
Antiquarian booksellers--Pictorial
works.
 | LCGFT: Illustrated works.
Classification: LCC Z278 .S64 2018 |
DDC 381/.45002--dc23
LC record available at https://lccn.loc.
gov/2018001266ISBN: 978-1-4236-5-
0430

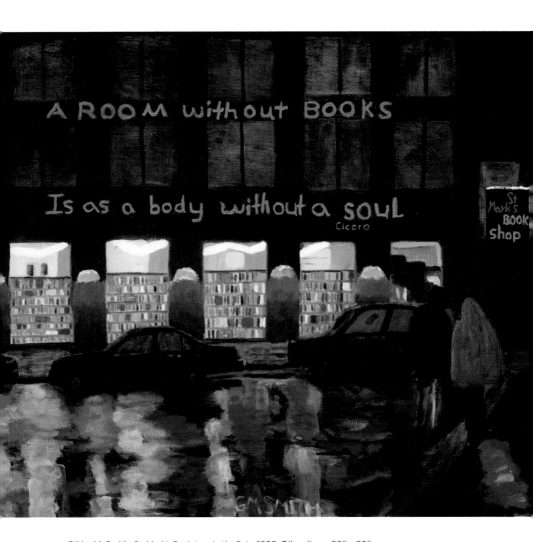

Gibbs M. Smith, *St. Mark's Bookstore in the Rain*, 1995. Oil on linen, 20" × 30".

—
5

Contents

City Lights Bookstore
San Francisco, California

———— • ————

Founded in 1953 by Lawrence Ferlinghetti and Peter D. Martin, City Lights is a historic literary hangout that has attracted dynamic individuals and promoted freedom of thought and ideas ever since it opened.

City Lights' regulars over the years have included Jack Kerouac and poet Allen Ginsberg, and the store helped to establish new guidelines regarding freedom of speech after publishing Ginsberg's poem "Howl" and successfully defending the work in court.

City Lights' large inventory of books reflects its support of progressive ideas and artistic freedom. The staff makes an effort to promote non-mainstream, thought-provoking titles, from gender studies to world literature to theological debate and much more. The store's selection of poetry and small press books is particularly impressive.

Gibbs M. Smith, *City Lights Bookstore,* 1988. Oil on canvas, 36" × 40".

CiTY Lights Bookstore
San Francisco

POCKET BOOKS

I think that I still have it in my heart Some day to paint a Bookshop with front yellow and pink in the evening... like a light in the midst of darkness

Vincent

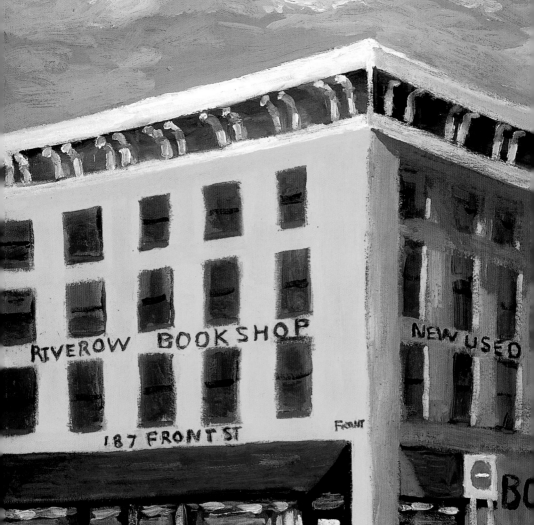

Riverow Bookshop
Owego, New York

———————— • ————————

Riverow Bookshop began in 1976 as a small used bookstore and moved into their current building in 1983, restoring the exterior to its Victorian style. The store has grown to offer three floors of books that are open to the public, as well as author readings, book clubs, and social events.

Second generation owner, Laura Spencer Eberly, builds book sculptures and paper craft displays to captivate booklovers and wanderers alike. The bookshop, consisting of 50,000 new, used, and rare books, is open seven days a week and is a centerpiece amidst Owego's downtown historic shopping district.

Riverow Bookshop's first proprietor, John Spencer, is proud of his "second edition" and passing on the spirit of volunteering and community activism. Riverow has been active in the community, participating with the area merchants to make Owego a vibrant special place to live and visit. Having contributed to the creation of a local swimming pool, a senior center, neighborhood park improvements, and also promoting the local arts and agriculture, Riverow is truly an asset to its community.

Gibbs M. Smith, *Yellow Bookstore,* 2005. Oil on linen, 16″ × 20″.

Kramerbooks & Afterwords
Washington, D.C.

———— • ————

Located in the Dupont Circle neighborhood and surrounded by universities and research institutions, Kramerbooks & Afterwords is home to a diverse collection of titles. The store's customers are sophisticated, well read, intelligent, and interesting. This stimulating bookstore is livelier than most thanks to its bar, full-service restaurant, and operating hours—"open early to late seven days a week, all night Friday and Saturday." There is late supper and brunch on weekends and live music Wednesday to Saturday nights.

Kramerbooks is owned and operated by Bill Kramer, who grew up in the book business. His father opened Sidney Kramer Books at the end of World War II and operated it until his death in 1968. Bill took over as manager of Sidney Kramer Books, then opened his own store, Kramerbooks & Afterwords, in 1976.

Gibbs M. Smith, *Kramerbooks, Washington, D.C.,* 2009. Oil on linen, 16" × 20".

———

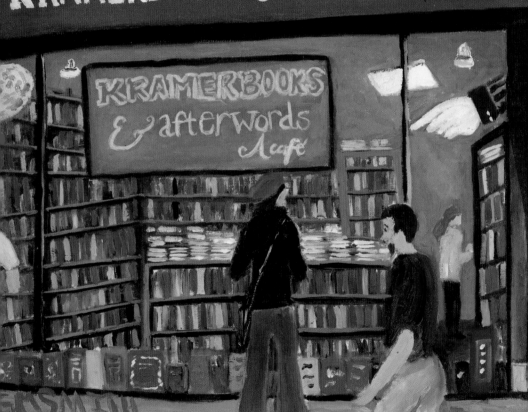

"Leaving any bookstore is hard, especially on a day in August, when the street outside burns and glares, and the books inside are cool and crisp to the touch; especially on a day in January, when the wind is blowing, the ice is treacherous, and the books inside seem to gather together in colorful warmth. It's hard to leave a bookstore any day of the year, though, because a bookstore is one of the few places where all the cantankerous, conflicting, alluring voices of the world co-exist in peace and order, and the avid reader is as free as a person can possibly be, because she is free to choose among them."

—Jane Smiley

Gibbs M. Smith, *Dutton's Beverly Hills,* 2007. Oil on linen, 16" × 20".

Garcia Street Books

Santa Fe, New Mexico

Garcia Street Books has been a neighborhood landmark in Santa Fe's East Side for more than twenty-five years. The store is supported by longtime residents, second-home residents, and the almost year-round flow of tourists. The store, through five owners, has continued to be well loved by the community for its well-curated selection of books that allows for engaging the senses in pursuit of literary works. The display approach—covers facing forward—supports this multisensory experience and encourages touching, talking, and browsing. The book choices reflect the community's wants and interests, offering an unusual assortment of art, style, and cooking, a unique section focused on living well, as well as literary fiction and serious nonfiction, both new and classic.

Regulars of the bookstore are fiercely loyal and order their books through the store rather than online retailers. It is common to find patrons stopping in the store to share with the owner the latest reviews from the *New York Times,* PBS, or other respected sources. These visits serve to shape and influence book selection. Looking to the future, there will be a focus on providing a personal sense of place, where patrons can interact with each other, while opening amazing places for the mind and spirit to go. In a community where the pace is more deliberate and interactive and filled with so many people of great artistic, cultural, and literary talent, Garcia Street Books will continue to be a beloved friend.

Gibbs M. Smith, *Garcia Street, Santa Fe,* 2009. Oil on linen, 16" × 20".

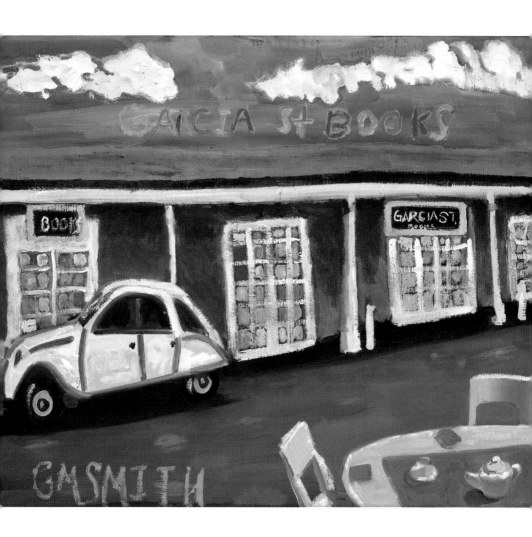

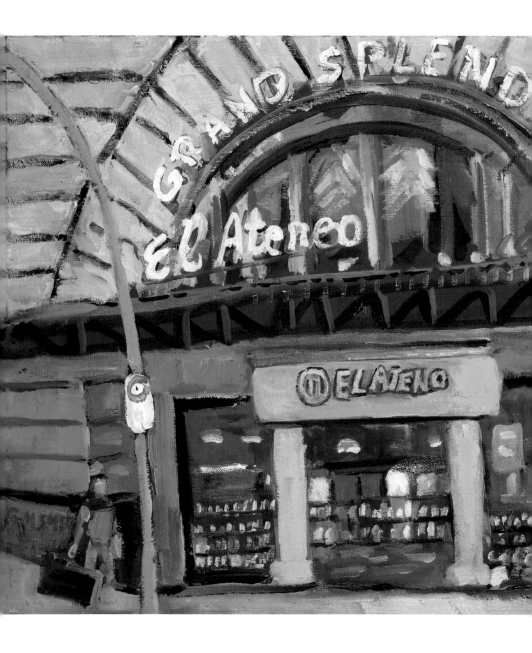

El Ateneo Grand Splendid
Buenos Aires, Argentina

This store has perhaps the most unusual location—in a former opera house in Buenos Aires. Originally built by Argentine entrepreneur Max Glücksmann, the Teatro Grand Splendid opened in May 1919 as a live theater with a seating capacity of 1,050. In 1924, a radio station, LR4 Radio Splendid, began broadcasting from the upper floor of the building, where Glücksmann's recording studios were also located. Many great tango artists of the day made their first recordings there, and tango contests were also held annually in the theater. It was converted into a cinema in the late 1920s, operating until its closure in the late 1990s. Opening as a bookstore in 2000, El Ateneo is possibly the most luxurious bookshop in the world with its cherubs, marble columns, elaborate sconces, and balcony and domed ceiling adorned with paintings by Italian artist Nazarino Orlandi. You can even enjoy a cup of coffee in the stylish café, which is located on the former stage.

On the ground floor in the space once occupied by armchairs, you will find rows upon rows of bookshelves holding a vast selection of art, architecture, cinema, cookbooks, novels, dictionaries, health, and business books, mostly in Spanish; however, you can also find an interesting selection of English books as well.

Gibbs M. Smith, *El Ateneo, Buenos Aires,* 2009. Oil on linen, 16" × 20".

Kepler's Books

Menlo Park, California

For more than sixty years, Kepler's has been the intellectual and cultural hub for the community that the world now knows as Silicon Valley. Founded in 1955 by peace activist Roy Kepler, Kepler's led the paperback revolution in the San Francisco Bay Area in the 1950s and '60s. It democratized reading by successfully using the "disruptive technology" of the era—35-cent paperbacks! The bookstore soon blossomed into a cultural epicenter, attracting a loyal following among Beat intellectuals, pacifists, students and faculty of Stanford University, and those in surrounding communities interested in serious books and ideas. The Grateful Dead performed at Kepler's early in their career, and they, along with folk singer Joan Baez, often held impromptu salons with local community leaders at Kepler's to discuss ideas, political action, and music.

In 2012, the Kepler's 2020 program began to systematically transition Kepler's from a family-owned bookstore into a community-owned and community-operated institution with a sustainable business model. Kepler's now operates with an innovative structure that includes three organizations, all with different business models but with a shared vision and values. These include a for-profit bookstore with a social mission, a nonprofit organization called Kepler's Literary Foundation that produces literary and cultural programs, and an online monthly subscription service called GiftLit that helps customers gift high quality books.

Today Kepler's operates in a radically democratic and transparent manner to serve its community of customers, authors, staff, publishers and other suppliers, local schools, local libraries, and nonprofit partners.

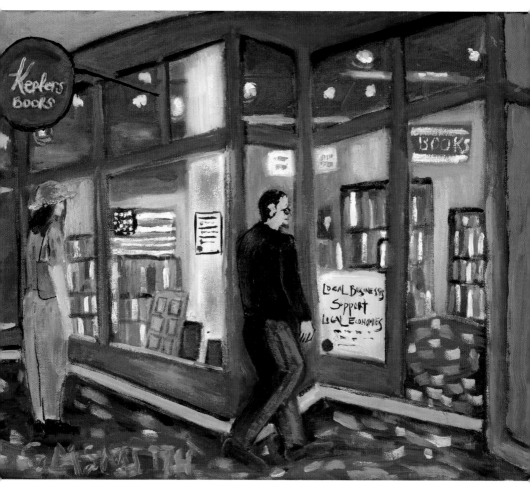

Gibbs M. Smith, *Kepler's,* 2009. Oil on linen, 16" × 20".

Barnes & Noble
at Union Square

New York, New York

"Bookselling is, of course, a vocation, but it is also an avocation, an art, and a passion. The magnificent Queen Anne-style building that our bookstore occupies is the Century Building, formerly the home of *Century Magazine*, Century Publishing Company, and *Saint Nicholas Magazine* for children. For several decades, many of the finest authors and artists in America roamed its high-ceilinged rooms, mingling with their editors. Walt Whitman, Stephen Crane, Edith Wharton, Frederic Remington, and N. C. Wyeth were just a few of the prominent contributors to the publications. Even Ulysses S. Grant and Theodore Roosevelt were Century authors.

"If you walk through our Union Square store these days, you might spot a young poet heading toward the registers with a copy of *Leaves of Grass* or a new bestseller. Head upstairs and you might be treated to a live event featuring Nick Hornby or John Grisham; Toni Morrison or Don DeLillo; a poet laureate or a rock star; a White House occupant, past or future. One night, we even hosted an upstart author named Barack Obama.

"We at Barnes & Noble find that what continues and what sustains us is our commitment to connecting writers and artists to readers."

—Steve Riggio, CEO of Barnes & Noble, Inc. (2002–2010)

Gibbs M. Smith, *Bookstore, Union Square, New York,* 1997. Oil on linen, 16" × 20".

Chaucer's Bookstore
Santa Barbara, California

———•———

Chaucer's Bookstore opened in 1974. It was founded by Mahri Kerley, who is regularly recognized as one of California's legendary book people. This is one of the most successful independent bookstores in California and has a very loyal clientele.

Chaucer's has a strong literary offering, including many British and Canadian imports and academic titles not usually found in bookstores off university campuses. Chaucer's also serves as a source for local interest such as history and nature.

Gibbs M. Smith, *Santa Barbara Bookstore,* 2006. Mixed media, 16" × 20".

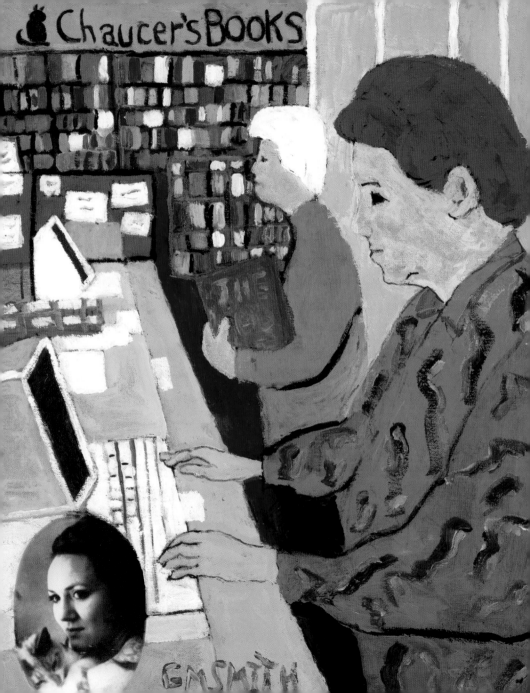

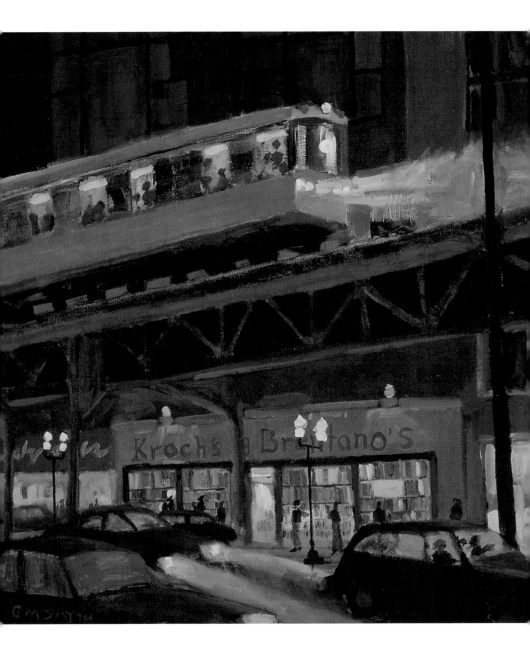

Kroch's & Brentano's
Chicago, Illinois

In Chicago, one of the venerable bookselling institutions for years was Kroch's & Brentano's. Kroch's was opened in the early part of the twentieth century by Adolph Kroch and was later managed by his son Carl Kroch. In the early 1930s, Kroch's bought Brentano's and made the Kroch's Chicago-area stores into one of the nation's most vital retail bookselling institutions by the early 1960s. The store on Wabash, under the "El" train, was Kroch's flagship location and one of America's foremost bookselling centers for well over fifty years. Several very notable booksellers were associated with this store, including Wendell Goodpasture, Bill McCarthy, Doris Laufer, and Bill Rickman.

The store closed in 1995, marking a definite conclusion to a magnificent period of Chicago bookselling.

Gibbs M. Smith, *Kroch's & Brentano's Bookstore, December Rush Hour on Wabash Avenue, Chicago,* 1996. Oil on linen, 16" × 20".

Green Apple Books
San Francisco, California

Located on Clement Street in San Francisco, Green Apple Books has been owned and operated by Kevin Ryan, Pete Mulvihill, and Kevin Hunsanger since 1999; it was originally opened in 1967 by Richard Savoy. Green Apple has three floors of crooked aisles, secret alcoves, and hidden stairways—a perfect place for booklovers to lose themselves or find something unexpected. With the store's very knowledgeable and friendly staff, you can often find titles at Green Apple that you won't find in other bookstores.

"The art of bookselling to me means embracing that word 'independent,' being our own store and not necessarily everybody's store. Some people don't like Green Apple because they think it's a little messy or it's just not their cup of tea. But the people that like it like it ferociously. Our customers want a place that's their own, and they're more loyal as a result than they would be if they could get the same experience shopping anywhere else."

—Kevin Ryan, co-owner of Green Apple Books

Gibbs M. Smith, *Green Apple,* 2008. Oil on linen, 16" × 20".

Maria's Bookshop
Durango, Colorado

Located on Main Avenue in Durango, Colorado, Maria's Bookshop is a local treasure that is dedicated to its community. Skis, sleds, and snowshoes on the walls emphasize the regional flavor of this store, which proudly celebrates the history, culture, and landscape of Durango and the entire Southwest. In fact, Maria's Bookshop isn't named for an owner or founder of the store; rather, it's a tribute to Maria Martinez, the famous potter from the San Ildefonso Pueblo, which is located in neighboring New Mexico.

It seems that everyone who works at Maria's is an outdoor enthusiast who loves the mountain country as well as books. The company uses wind power, encourages its employees to bike to work, provides free trolley tokens to its customers, uses green cleaning products, and even has beehives on its roof. The store supports the community by carrying and promoting books by local authors, as well as by selling locally made products such as jewelry, journals, and greeting cards. The citizens of Durango respond by making Maria's a successful business year after year.

Gibbs M. Smith, *Maria's,* 2009. Oil on linen, 16" × 20".

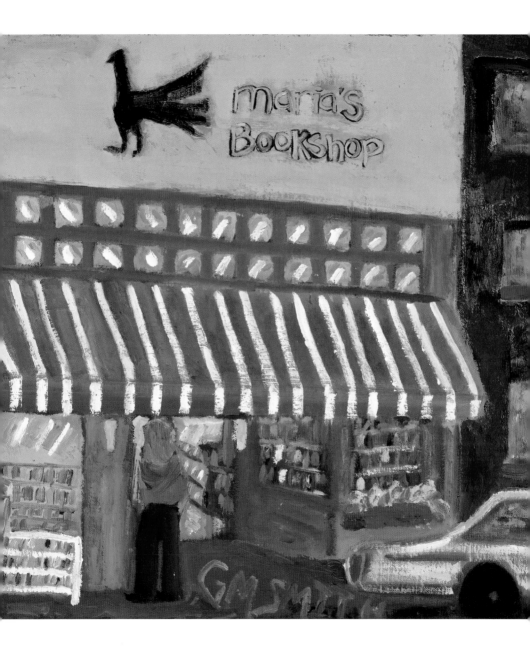

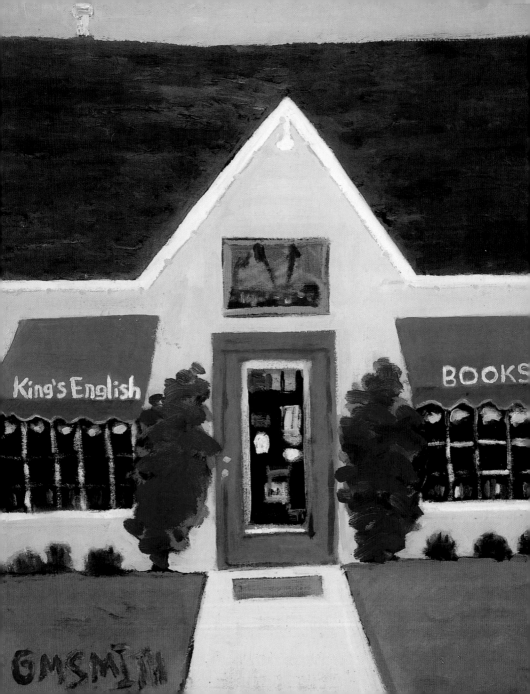

The King's English Bookshop
Salt Lake City, Utah

"I truly believe that without independent businesses, a community withers and dies. Fortunately the indie movement is gaining ground all across the country, and independent bookstores are at the heart of that movement."

—Betsy Burton, owner of The King's English Bookshop

Betsy Burton opened The King's English Bookshop in 1977 with then-partner Ann Berman. When Berman left in 1985, Burton ran the store alone (with the help of many excellent booksellers) until 1987, when Barbara Hoagland became a partner. The King's English is well known and respected in the local community as well as the community of independent bookstores nationwide. Betsy is a hands-on bookseller who does her homework. She shares her knowledge and passion nonstop with customers about the books she sells. Customers rely on her opinion and are never disappointed. She is a wonderful bookseller and a valuable member of the bookselling community, and she understands the significant role independent bookstores have in their individual neighborhoods. Anne Holman has been Betsy's partner in the bookstore since 2014 and in 2017 they celebrated forty years of matching books to readers.

Gibbs M. Smith, *Betsy's Bookstore,* 2004. Oil on linen, 16" × 20".

Politics and Prose Bookstore
Washington, D.C.

Politics and Prose was founded by Carla Cohen and Barbara Meade in 1984. This store has become one of the most honored independent book-stores in the country and has grown to twelve thousand square feet, with fifty employees. Politics and Prose has an impressive schedule of events, with authors and lectures occurring at least once a day. The store also has an extensive number of book groups that are led by the store's staff.

The name Politics and Prose fits with the clientele's interests, which include government and public policy, American history and biography, fiction, poetry, children's books, and much more.

Gibbs M. Smith, *Politics & Prose,* 2006. Oil on linen, 16" × 20".

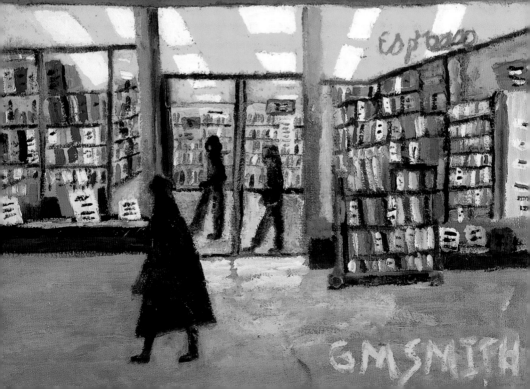

POLITICS & PROSE

BOOKSTORE 5015 BOOK STORE

Espresso

GMSMITH

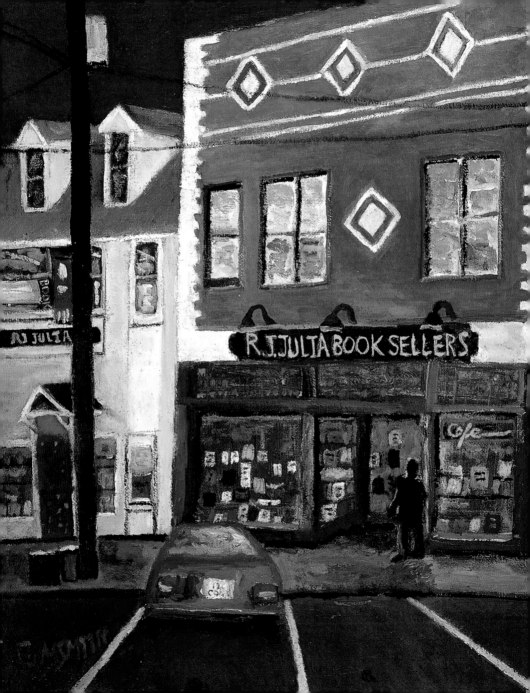

R.J. Julia Independent Booksellers

Madison, Connecticut

R.J. Julia Booksellers, located on the shoreline of Madison, Connecticut, was founded by Roxanne Coady in 1989. The building originally housed Nick's Bar and Grill but was abandoned; it was covered in soot and grease when Roxanne purchased it. The store now consists of two buildings, including the R.J. Café and enough room to hold the more than two hundred author events presented each year.

The store is not named for one individual but is a combination: "R" for Roxanne, "J" for husband Kevin's middle name, and "Julia" for Roxanne's grandmother and source of inspiration.

Gibbs M. Smith, *R.J. Julia,* 2006. Oil on linen, 16" × 20".

Builders Booksource
Berkeley, California

"We started Builders Booksource with high hopes, seeing part of our mission as bringing together two disparate groups we targeted as a significant part of our market—architects and builders. Builders Booksource provides a venue where these professionals mix, where questions are raised and problems solved. Over the years, our reputation as a resource has grown. In today's information-jammed society, where books are often considered just another commodity, we continue to see our role as problem solvers, not only for the professionals we cater to, but also for the lay people that frequent our street. We and our customers have found that books are so much more than a commodity—they inspire and teach, provide confidence and direction, and in the end become that comfortable presence on our bookshelf, ready to be drawn on again and again. As booksellers, we take tremendous pride and enjoyment from helping our customers answer that question, solve that problem. As difficult as the business of bookselling is these days, we continue to be inspired by and enjoy the process."

—George and Sally Kiskaddon, partners, Builders Booksource

Gibbs M. Smith, *Christmas on Fourth Street, Berkeley,* 2009. Oil on linen, 16" × 20".

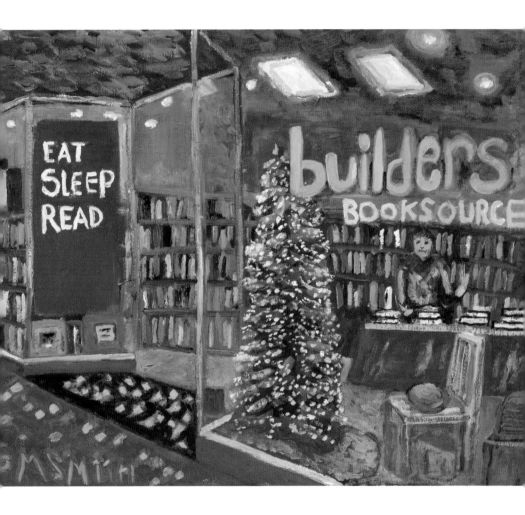

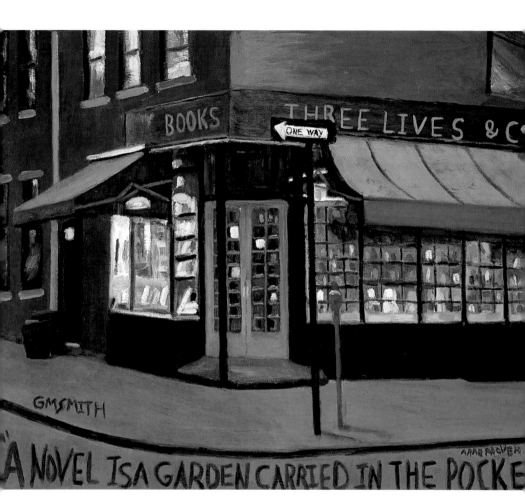

Three Lives & Company
New York, New York

Located in New York's Greenwich Village, Three Lives & Company was founded in 1978 by a group of three friends, Jenny Feder, Helene Webb, and Jill Dunbar. In 2001, the owners sold the store to Toby Cox, who was then working at Random House. Toby jumped at the chance, feeling that Three Lives was exactly the kind of bookstore he would want to own. He carries the sorts of things that he and his staff like to read—fiction, poetry, biography, travel, art.

This bookstore is a rare place. Its shelves are intentionally left unlabeled so that you'll approach its friendly staff, hopefully ending up in a lively conversation about books. Its displays are arranged artistically, and you get the feeling that the staff has a real regard for books not only as vessels for information, but also as physical objects, as works of art.

Gibbs M. Smith, *Three Lives Bookstore, Greenwich Village,* 1993. Oil on canvas, 16" × 20".

Village Books

Bellingham, Washington

Dee and Chuck Robinson founded Village Books on June 20, 1980, after traveling from the Canadian border down the West Coast to the Bay Area looking for a place to start a bookstore. They explored place after place before settling on the Fairhaven neighborhood of Bellingham, Washington.

Over the years the store has expanded several times, going from 1,500 square feet to about 10,000 in its current space. The new store space also opens into Paper Dreams, a card and gift store owned by Dee and Chuck, and includes two cafés—the Colophon Café and Book Fare. With the move, used books and remainders were also integrated into all sections of the store.

Chuck and Dee are very involved in their community and in the bookselling world. They have both served on boards of notable bookselling associations and participate actively in local organizations that aid community members. Village Books was named the 2008 Outstanding Philanthropic Small Business in the State of Washington.

Gibbs M. Smith, *On the Way to Alaska*, 2009. Oil on linen, 16" × 20".

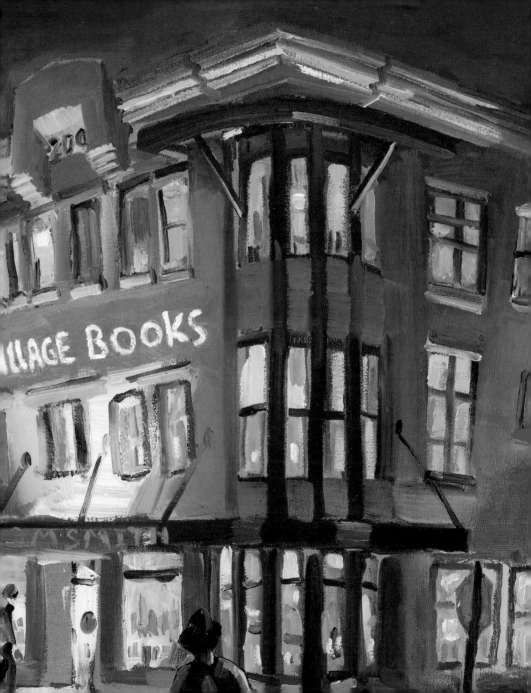

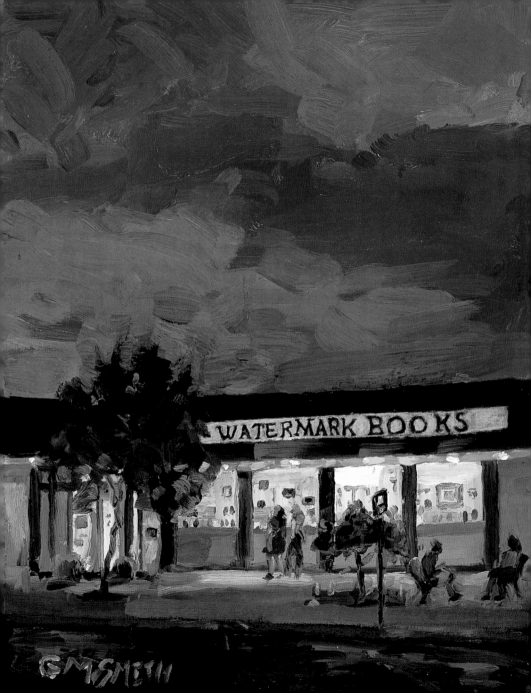

Watermark Books & Café
Wichita, Kansas

Watermark Books in Wichita, Kansas, is owned by Sara Bagby and Bruce Jacobs and was founded in 1977. It is located in the College Hill neighborhood of Wichita, which has many historic homes and a marvelous shopping area where Watermark and its ancient elm tree have been located these many years.

Watermark is known for its friendly staff, its frequent author events, its book clubs, and its café, serving coffee, pastries, and salads, along with sandwiches such as the Moby Dick (tuna salad) and Dante's Inferno (roast beef, red peppers, and pepper jack cheese). Watermark Books & Café is a gathering place for the members of its community.

Gibbs M. Smith, *Watermark Books,* 2002. Oil on linen, 16" × 20".

George Bayntun

Bath, United Kingdom

George Bayntun set up his bookshop and bindery in Bath in 1894, and in 1939 he moved the business to its present location on Manvers Street. The building dates to 1901 and was originally the Postal Sorting Office. It has changed little over the years, and the benches at which the mail was once sorted are now used for bookbinding—all of which is done by hand, in the old-fashioned way. The business was managed for almost fifty years by George's grandson, Hylton, and is now run by his son, Edward. The shop remains open to visitors, though it closes for an hour at lunch.

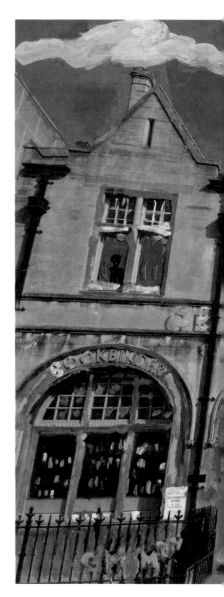

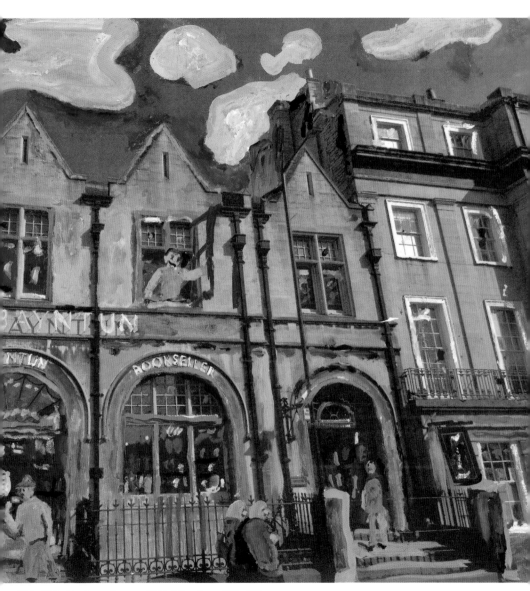

Gibbs M. Smith, *George Bayntun,* 2016. Oil on linen, 20" × 16".

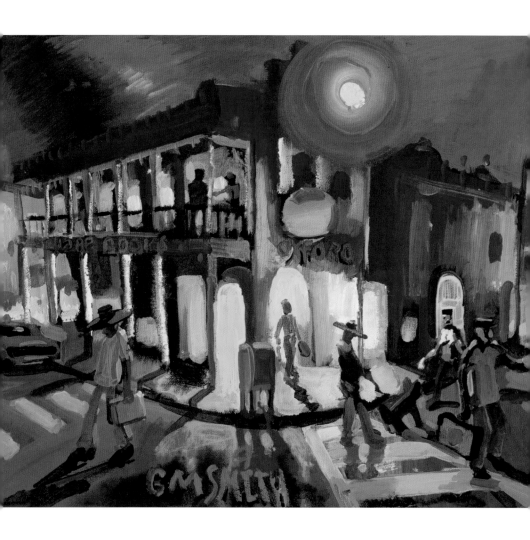

Square Books

Oxford, Mississippi

Square Books began in four second-floor rooms of a building on the town square in Oxford, Mississippi, which then was known primarily for two things: the domain of one of America's greatest writers, William Faulkner, and the home of the University of Mississippi, where, in 1962, a crisis over desegregation resulted in riots that killed two people and nearly destroyed this community's psyche.

From the night Square Books opened in 1979—when nary a writer lived in Oxford—the store has grown to occupy three historic buildings about one hundred feet apart on this same square. This was made possible for numerous reasons, including the many visitors who come here to see Rowan Oak, Faulkner's home, and the amazing support of people who have lived here and understood that a vibrant bookstore might serve to right some of the wrongs of 1962.

In 1980 Willie Morris moved to Oxford, Mississippi. Barry Hannah followed in 1982. Excellent booksellers signed up with Square Books. Author events at the store began to grow. Larry Brown and John Grisham lived in Oxford when their first books came out, and today well over two dozen writers and an army of readers form a literary constellation of which Square Books is one very glad and grateful part.

Gibbs M. Smith, *Square Books,* 2010. Oil on linen, 20" × 16".

Parnassus Books

Nashville, Tennessee

"Amazon doesn't get to make all the decisions; the people can make them by how and where they spend their money. If what a bookstore offers matters to you, then shop at a bookstore. If you feel that the experience of reading a book is valuable, then read the book. This is how we change the world: we grab hold of it. We change ourselves."

—Ann Patchett, co-owner of Parnassus Books (excerpt from *The Bookstore Strikes Back*)

Gibbs M. Smith, *Parnassus Books,* 2015. Oil on linen, 20" × 16".

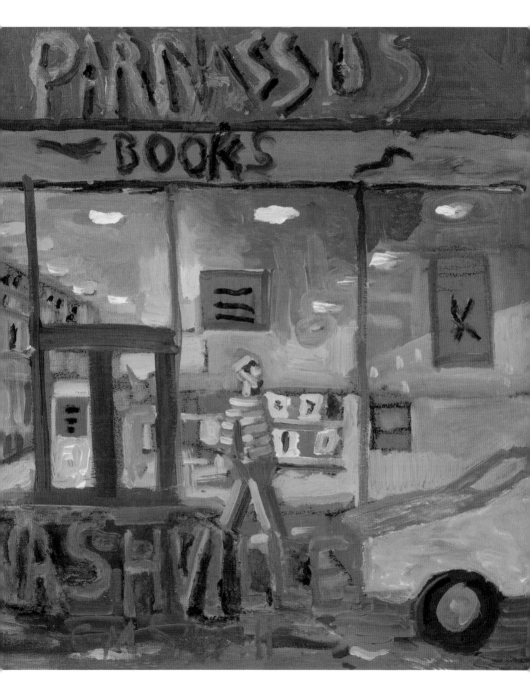

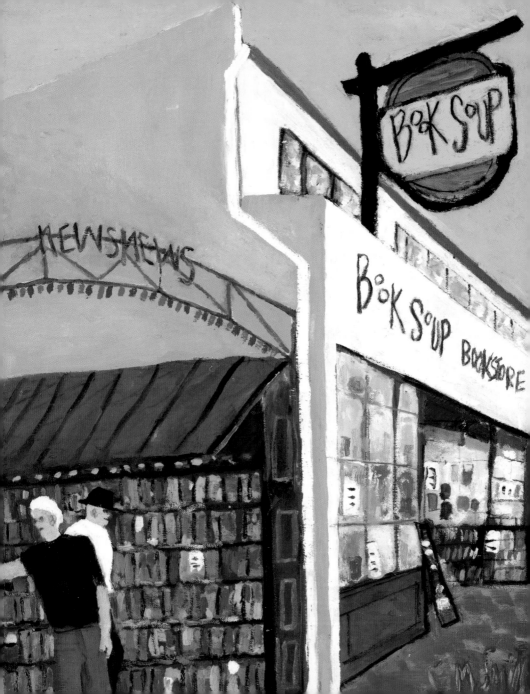

Book Soup

Los Angeles, California

———— • ————

Book Soup Bookstore, located on the Sunset Strip in West Hollywood, California, has been serving the Los Angeles book community since it first opened in 1975.

As one of the last large independent bookstores, with over sixty thousand titles in stock, Book Soup caters to the specialized interests of its clientele with a diverse inventory of literary fiction, nonfiction, film, art, music, photography, and more. The store is as famous for its high profile signing events—which have featured authors and celebrities including Gore Vidal, Edward Albee, and Robert Wagner—as it is for its walls of bookshelves stacked from floor to ceiling. There is virtually something for everyone to be found in this wonderful store.

Glenn Goldman, who founded Book Soup in 1975, passed away in January 2009. After his passing, there was an outpouring of affection by customers, staff, authors, colleagues, and the community, who remembered a kind, smart, generous, wryly humorous man whose dedication to contributing books and culture to his community was appreciated and treasured.

Gibbs M. Smith, *Book Soup, Hollywood,* 2008. Oil on linen, 16" × 20".

Rizzoli Bookstore

New York, New York

The origins of the building at 31 West Fifty-Seventh Street between Fifth and Sixth Avenues in New York reach back to the late nineteenth century, when the structure was a private residence. It was one of many that lined both sides of Fifty-Seventh Street. Neighbors across the street included the families of James Roosevelt and Theodore Roosevelt, Sr., the father of President Theodore Roosevelt. Eventually the commercialization of nearby Fifth Avenue overflowed onto Fifty-Seventh Street. Because of Carnegie Hall's proximity, from 1890 onward piano manufacturers established their showrooms here. In the 1920s, 31 West Fifty-Seventh Street was altered to its present appearance for the Sohmer Piano Company. Rizzoli—renowned publisher of art, architecture, interior design, fashion, photography, and other books on the visual arts—opened their flagship store here in 1985, where it thrived in this particular location as a literary landmark in New York for twenty-nine years.

Gibbs M. Smith, *New York, West Fifty-Seventh Street,* 2007. Oil on linen, 16" × 20".

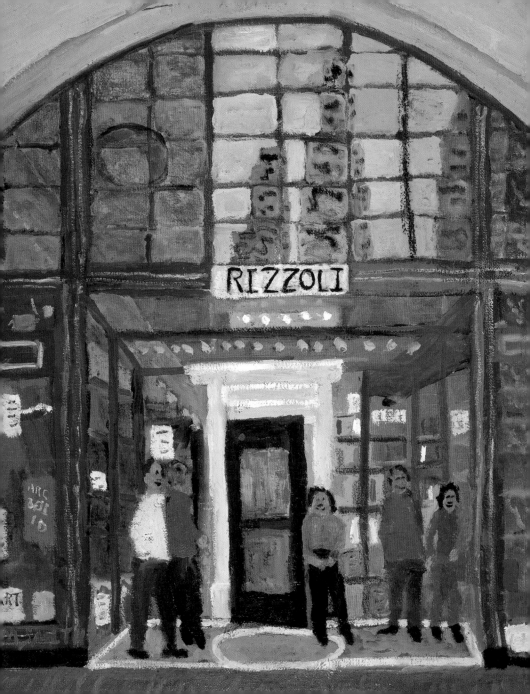

Tattered Cover Book Store
Denver, Colorado

Tattered Cover has been a fixture on the Metro Denver literary scene since it was founded in 1971. Joyce Meskis, the former owner, helped define the design and ethos of the modern indie bookstore with warm, inviting environments, ample seating space, and a wonderfully curated selection of books. The four Tattered Cover locations that exist today provide a unique experience for customers, hosting more than 500 events a year.

Gibbs M. Smith, *The Tattered Cover Book Store,* 2002. Oil on linen, 16" × 20".

Bank Street Bookstore
New York, New York

Bank Street Bookstore occupies a proud place within the Bank Street community as a place that understands the importance of stories to help young readers grow and learn. Books for infants to young adults are available—from classic to modern, well-known to obscure. The bookstore's selection also includes materials for teachers, education professionals, and parents.

Customers who visit the store regularly know they will receive helpful information about books that interest kids in reading from an early age through high school. Booksellers engage customers in conversations that help identify interests so book suggestions are customized for each reader.

The store's history is linked to traditions going back to the 1930s when author Margaret Wise Brown became a member of the Bank Street Writers Lab. Brown was a driving force behind the "Here And Now" movement in children's books, conceived ten years prior by Bank Street College founder Lucy Sprague Mitchell. Mitchell and Brown oversaw the creation of hundreds of innovative works of literature that—unlike that era's conventional children's books laden with moral instruction—reflected back children's intimate daily experiences and inner lives.

The Bank Street Writers Lab still flourishes as a component of the Bank Street Center for Children's Literature. It is this pivotal place that Bank Street College occupies in contemporary children's literature that explains why forty years of nurturing and maintaining one of the world's best children's bookstores has been a mission-driven activity for the Bank Street College of Education.

Gibbs M. Smith, *Bank Street Bookstore, New York,* 2005. Oil on canvas, 18" × 24".

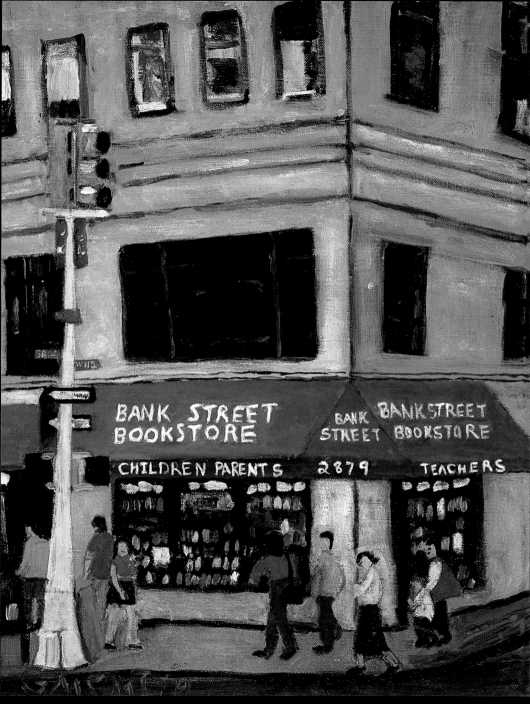

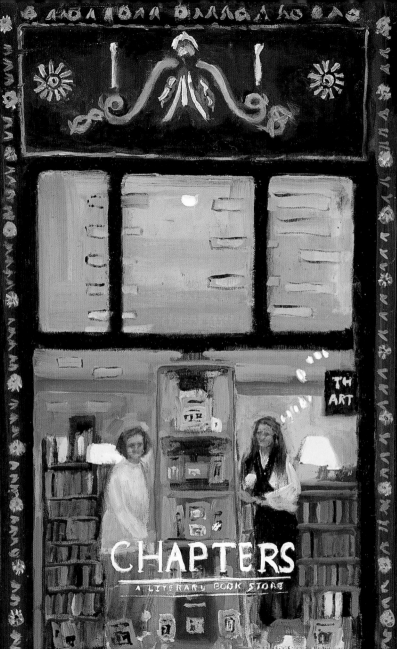

CHAPTERS
A LITERARY BOOK STORE

EM SMITH

Chapters: A Literary Bookstore
Washington, D.C.

Chapters, founded in 1985 and owned by Terri Merz and Robin Diener, was an elegant and personal store, an oasis of civility. Its program of readings by internationally respected authors gave the store the aura of a literary salon. The passions, tastes, and enthusiasm of the owners were reflected in the wide range and selection of books that began with an immense poetry section, and continued on to literary fiction old and new, literature in foreign languages, the culinary arts, children's literature, natural history, and more, which catered to serious readers and browsers alike. They also hosted many other activities, such as the annual Marcel Proust birthday celebration, the annual George Eliot memorial lecture, and a celebration of Anthony Powell's *Dance to the Music of Time*. The store's slogan, from Horace, was *littera scripta manet* (the written letter remains).

The store closed its doors permanently in 2007.

Gibbs M. Smith, *Chapters,* 1996. Oil on linen, 16" × 20".

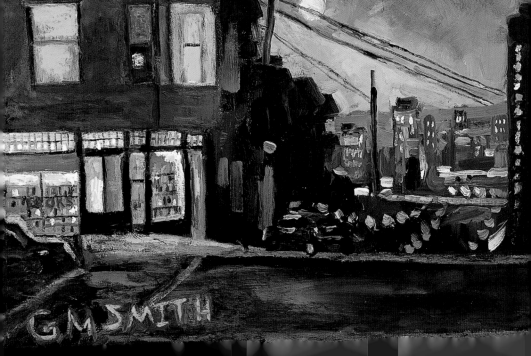

Christopher's
BOOKS
SanFrancisco

G M SMITH

Christopher's Books

San Francisco, California

———•———

Christopher's Books was founded in 1991 by Christopher Ellison who hailed from New Zealand. Located on Potrero Hill in San Francisco, the space occupied by the bookstore originally housed an old-fashioned pharmacy. The shop is only 650 square feet, and many of the original pharmacy fixtures are still intact and used as book displays. The entrance is on a street corner where French doors invite the public to come in and browse. Mr. Ellison returned to New Zealand in 1992 to operate a small dairy farm, and Tee Minot took over operations. In 1994, Tee bought the business and owns and operates it today.

The Potrero Hill community is passionate about books and has been very supportive of this well-stocked, well-staffed, pet-friendly corner bookshop. Christopher's has become a fixture in the community and is a beloved bookstore of San Francisco.

Shakespeare & Co.

New York, New York

Shakespeare & Co. opened in 1981 at its original location on Broadway and 81st Street, in the heart of the Upper West Side. Through the next two decades, it branched out to other parts of the city: the East Village, East 23rd Street, the World Trade Center, and Brooklyn. In 1996, it opened in what is now its only location, on Lexington Avenue and 69th Street.

In 2015, Shakespeare & Co. came under ownership of Dane Neller, former CEO of Dean & DeLuca, whose vision was to create a perfect trifecta of community, culture, and technology—with the addition of a café, authors' events, and the Espresso Book Machine, a state-of-the-art printer that prints quality paperbacks on demand.

Shakespeare & Co. looks to expand again in the tradition of independent bookstores serving as a cultural hub for their community.

Gibbs M. Smith, *Shakespeare & Co., Lower Manhattan,* 2008. Oil on linen, 16" × 20".

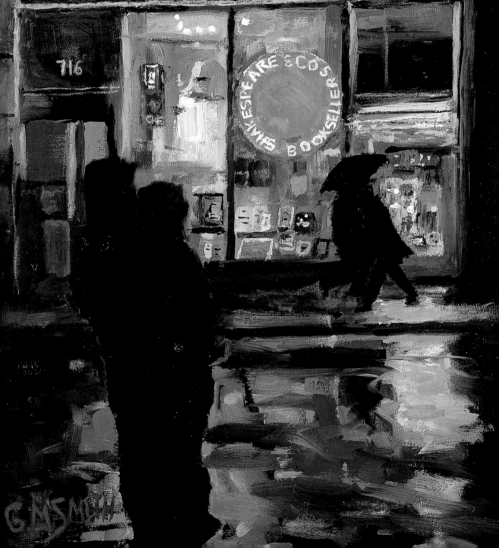

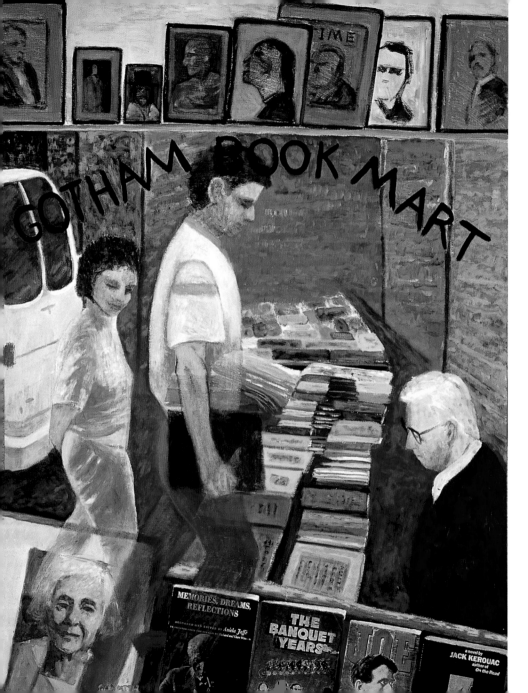

GOTHAM BOOK MART

MEMORIES, DREAMS, REFLECTIONS

THE BANQUET YEARS

a novel by JACK KEROUAC
author of On the Road

Gotham Book Mart

New York, New York

Gotham was opened in 1920 by Frances Steloff, a passionate booklover and businesswoman who continued to work in and nurture the store even after selling it to Andreas Brown in 1967.

The bookstore was frequented over the years by such writers and other artists as Theodore Dreiser, Arthur Miller, John Updike, J. D. Salinger, George and Ira Gershwin, Charlie Chaplin, Alexander Calder, Woody Allen, Saul Bellow, and Katharine Hepburn. Its walls held memorabilia of readings from such poets as Dylan Thomas and W. H. Auden. The artist Edward Gorey, a good friend of Andreas Brown's, launched his career at Gotham where Brown exhibited and sold his works when Gorey was still unknown. Customers loved the store for its out-of-the-ordinary selection and its eccentric atmosphere.

When Gotham Book Mart closed its doors in 2007, New York lost a significant cultural landmark. Located in the midst of New York's Diamond District, Gotham was known as a literary sanctuary that attracted writers and artists and promoted thought-provoking literature.

Gibbs M. Smith, *Frances's Bookstore, New York,* 1990. Oil on canvas, 16" × 20".

Jay's Book Stall

Pittsburgh, Pennsylvania

Founded and operated by Jay Dantry, Jay's Book Stall was in business in the heart of Pittsburgh's university, medical, and museum community for forty-nine years. The venerable shop was wall-to-wall, floor-to-ceiling books, and nearly five hundred photographs of Jay with visiting writers were featured along display panels, on counters, and in alcoves. The pictures included such writers as Kurt Vonnegut, John Updike, Stephen King, Erica Jong, and Pulitzer Prize–winning novelist and former Book Stall clerk, Michael Chabon. Jay also remembers the distinguished Broadway actors who, as students, used to spend hours perched on ladders in the drama section reading playbooks.

At the age of seventy-nine, Jay decided to retire and close his shop, disappointing the many die-hard customers who came to rely on him. Jay helped his customers find little-known literary gems and connected readers with authors through the hundreds of book signings and readings he held over the years. Jay leaves behind a legacy of a passion for books and a love of sharing that passion with everyone who walked through his doors.

Gibbs M. Smith, *Jay's Book Stall,* 2004. Oil on linen, 16" × 20".

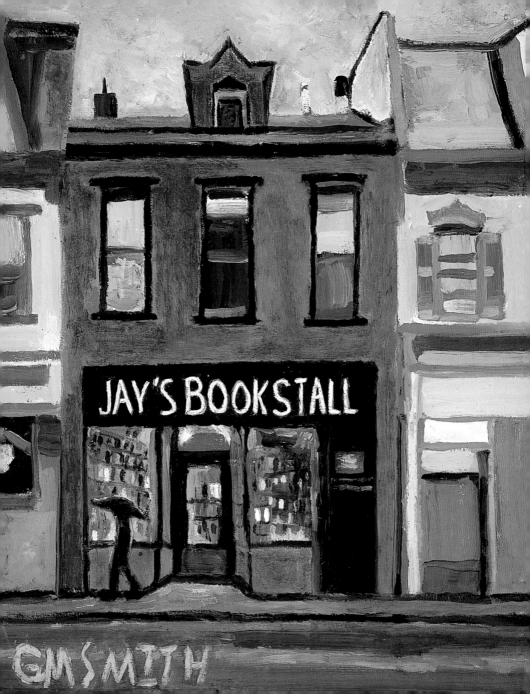

Prairie Lights Books

Iowa City, Iowa

Prairie Lights Books has been Iowa City's independent bookstore for forty years. The store features three stories of fiction, nonfiction, and poetry, a full floor dedicated to children's books, and the lively Prairie Lights Café. It is both a hangout spot for locals and a tourist attraction for book-lovers across the world. The store hosts nightly readings and has featured Stephen King, Roxane Gay, Colson Whitehead, Mary-Louise Parker, Amber Tamblyn, David Sedaris, and Lena Dunham. Prairie Lights has strong ties to the storied Iowa Writers' Workshop and benefits from Iowa City's designation as a UNESCO City of Literature. James Harris opened the store in 1978. Since 2008, co-owners Jan Weissmiller and Jane Mead, both graduates of the Writers' Workshop and published poets, have aimed to provide books for readers of all ages and with a diverse range of tastes.

Gibbs M. Smith, *Prairie Lights, Iowa City,* 2004. Oil on linen, 16" × 20".

Mrs. Dalloway's
Literary & Garden Arts
Berkeley, California

———— • ————

Owned by Ann Leyhe and Marion Abbott and founded in 2004, this store is managed with much style and taste. The name of the store comes from a book by Virginia Woolf of the same title, which was written the same year the store's building was constructed. A unique feature of Mrs. Dalloway's is the mannequin that takes center stage in the front window, stylishly dressed for each new season. In addition to fiction, children's literature, biography, politics, and history, Mrs. Dalloway's has a wonderful assortment of gardening books, as well as plants, flowerpots and vases, and an extensive collection of gardening magazines.

Gibbs M. Smith, *Mrs. Dalloway's*, 2008. Oil on linen, 16" × 20".

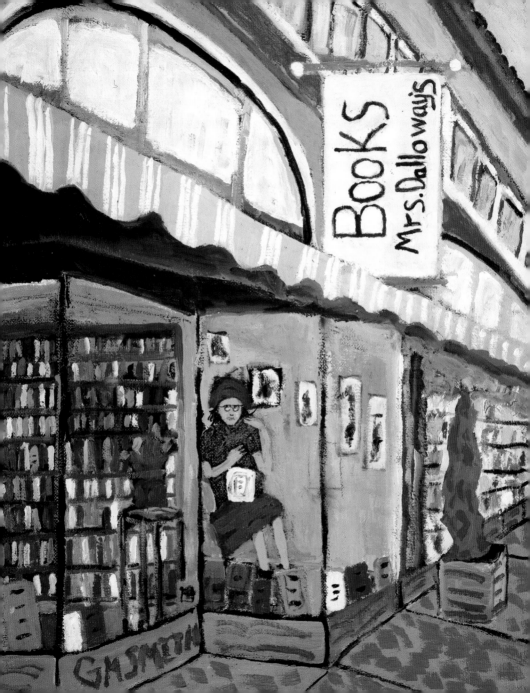

POWELL'S BOOKS
USED & NEW BOOKS
NOV 23 ANNIE LEIBOVITZ BOOK SIGNING 5 PM

GMSMITH

Powell's Books

Portland, Oregon

"My grandfather taught me that our job is to connect the writer's voice with the reader's ear and not let our egos get in between. My father taught me not only the love of the book itself but also how to love the business of bookselling."

—Emily Powell, owner of Powell's Books

Powell's roots began in Chicago, where Michael Powell, as a University of Chicago graduate student, opened his first bookstore in 1970. Encouraged by friends and professors, including novelist Saul Bellow, Michael borrowed $3,000 to open a bookstore and the venture proved successful.

Michael's dad, Walter Powell, a retired painting contractor, worked one summer with Michael in the Chicago store. He so enjoyed his experience that upon returning to Portland he opened his own used bookstore. Walter had the crazy notion of selling used books—both paperbacks and hardbacks—along with new books. The idea worked, and Powell's has been a beloved Portland institution ever since.

Four decades later, Powell's Books is a cornerstone of the community and continues to operate as a third-generation, family-owned business with Emily Powell at the helm.

A visit to Portland isn't complete without a visit to Powell's. The mammoth store, which takes up an entire city block with its thousands of books, is always buzzing with locals and tourists, who can end up browsing for hours. This painting of Powell's is at night, when the place is filled with intense and stimulating activity and romance.

Gibbs M. Smith, *Powell's,* 2002. Oil on linen, 16" × 20".

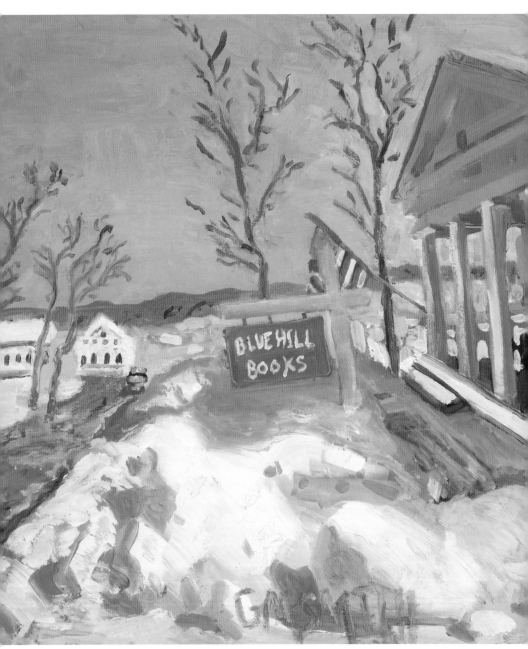

Gibbs M. Smith, *Blue Hill Books,* 2009. Oil on linen, 20" × 16".

"When I walk into a bookstore, any bookstore, first thing in the morning, I'm flooded with a sense of hushed excitement."

—Lewis Buzbee
The Yellow-Lighted Bookshop

Changing Hands Bookstore
Tempe, Arizona

"Changing Hands began as a dream on the porch steps of an alternative school for kids where Tom Brodersen, Gayle Shanks, and Bob Sommer met each other as volunteers. One day we talked about what we'd really like to do with our lives and the idea that we hatched was a cozy, socially responsible bookstore and community gathering place. A few years later, Tom bought a small used bookstore for $500—all he had at the time—and asked his friends to help him. Changing Hands opened on April Fool's Day, 1974, with a big interest in books and community service.

"I've always believed that a good bookstore is more than the books inside its walls. A good bookstore provides avid readers with a place not only to buy, but also to imbibe the essence of the magic of the written word. It exudes the passion of the booksellers, the desire by consumers for wonderful things to read, and the connection of those readers with authors and all things literary. A bookstore supports its reading community by bringing in authors so customers can 'hear' from them the sound of the very words they've written. It starts building readers by engaging children and their teachers in programs designed to inculcate the fun and value of reading at a very early age. It supports those readers as they grow by finding and sharing new books, new writers, new ideas with them through media, in-store displays, events, and story times. A bookstore builds a community around itself that supports and is supported by that community. It creates the literary landscape, it provides the space for the sharing of values, and is the underpinning of a free society where all ideas can be explored."

—Gayle Shanks, co-owner of Changing Hands

Gibbs M. Smith, *Arizona Bookstore,* 2009. Oil on linen, 16" × 20".

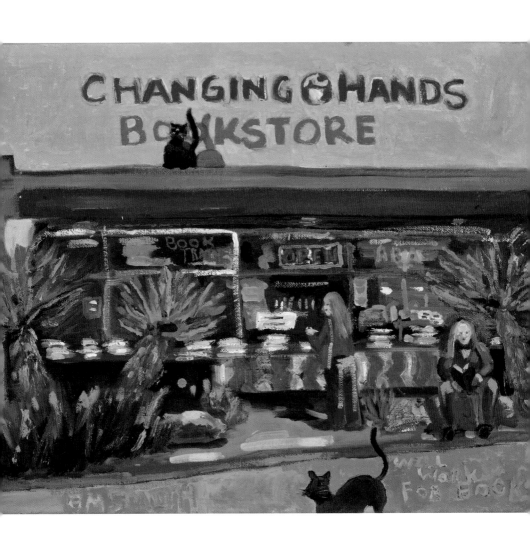

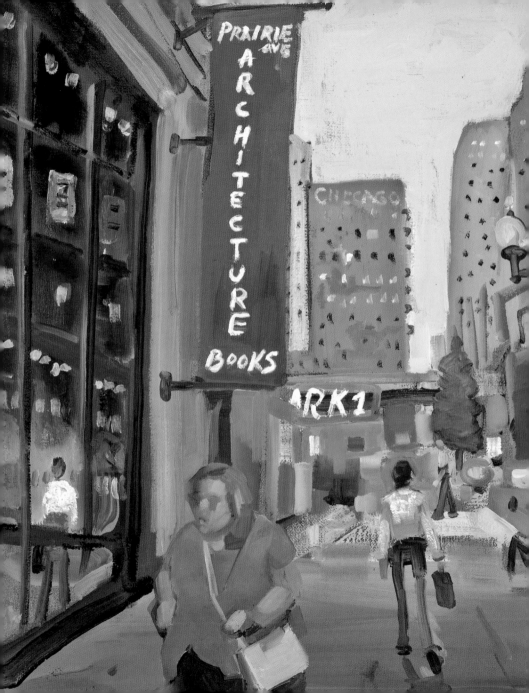

Prairie Avenue Bookshop
Chicago, Illinois

———— • ————

Prairie Avenue Bookshop was opened by Marilyn and Wilbert Hasbrouck in 1974. The Hasbroucks had founded the Prairie School Press in 1961 in order to publish books about Prairie School architecture. Following that, they founded the *Prairie School Review,* a quarterly journal that served as a forum for discussion about the architectural style. The Hasbroucks began selling books to subsidize publication of the journal, and this led to the opening of Prairie Avenue Bookshop.

The shop quickly became a mecca for all things architecture and design. Just visiting the store was an architectural treat. Wilbert Hasbrouck was an architect himself, and when the store moved to its quarters on Wabash Avenue, Wilbert designed a space with Prairie School and Chicago School influences. The store was even decorated with furniture by Frank Lloyd Wright, Mies van der Rohe, Le Corbusier, and others, and in its day provided a collection of titles both impressive and intelligent.

After thirty-five years of operation, the bookstore closed in August 2009.

Gibbs M. Smith, *Prairie Avenue Books,* 2009. Oil on linen, 16" × 20".

Shakespeare & Co.

Paris, France

Located across from Notre Dame Cathedral in Paris's Left Bank, Shakespeare & Co. is a cultural and social center for Parisians and visitors to the City of Lights. Shakespeare & Co. was founded in 1951 by George Whitman, then a student at the Sorbonne who had amassed a collection of English books during his studies. George took a cue from his friend Lawrence Ferlinghetti (poet, artist, and founder of City Lights Bookstore in San Francisco, California) and decided to open a bookstore. Since then, the store has welcomed writers, artists—and, indeed, anyone who walks through its doors—with open arms. Famous writers such as Henry Miller, James Baldwin, Langston Hughes, Anaïs Nin, and Allen Ginsberg browsed there, gave readings there, and even spent the night there—George keeps a room for traveling writers who need a place to stay.

The store is stocked floor-to-ceiling with books new and old. George encourages customers to stay and read all day if they like, and even borrow books if they can't afford to buy. Readings are held regularly, and aspiring writers can attend workshops in the store's upstairs library for a modest fee. Like the famous literary and artistic salons of the past, Shakespeare & Co. is an institution that nurtures writers, poets, and artists and cultivates contemplation and creativity.

Gibbs M. Smith, *Paris in the Spring,* 2009. Oil on linen, 16" × 20".

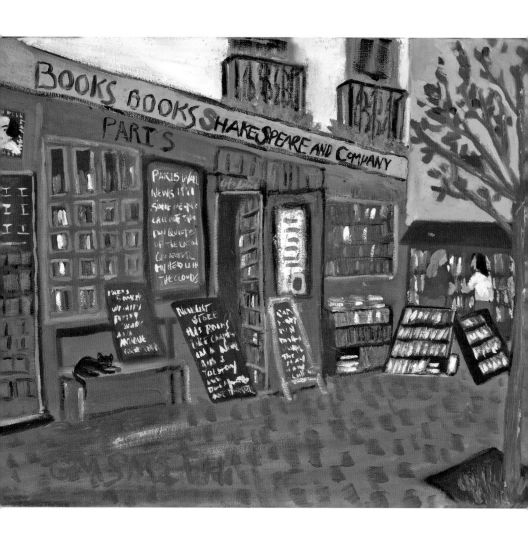

BOOKS & BOOKS

GASMITH

Books & Books

Coral Gables, Florida

———— • ————

"For me, the art of bookselling begins and ends with the notion of serving your community. Everything I do as a bookstore owner is an attempt to create that great, good place, where service, selection, and ambiance come together to celebrate the richness and diversity of literary culture, all the while providing a unique space where there is comfort in knowing that the free flow of ideas is honored and respected. Redefining the way our customer measures value is the tool by which Books & Books has been able to reassert this idea of the primacy of the third place. Value should not be measured only in terms of price; value, instead, has to be calculated by how well we serve our community, and how well we express this to our customer. The distinctive selection of books we carry, the readings, lectures and demonstrations we mount, the commitment to fostering a love of books and reading in children and teens, our next generation of readers, the sharing of our public space with community groups, from Amnesty International to a Tibetan Buddhist study collective, this is the value that we provide our community. And, it's most fortunate for us, in this very, very difficult climate for independent bookstores, that our community has responded, reaffirming their desire for the kind of a place that is Books & Books."

—Mitchell Kaplan, owner of Books & Books

Gibbs M. Smith, *Books & Books—Coral Gables, Florida,* 2007. Oil on linen, 18" × 24".

Warwick's

La Jolla, California

———— •◆• ————

The sun-soaked, seal lounge coves of La Jolla, California, are a long way from the humble riverfront shops of Mankato, Minnesota. Established by William T. Warwick in 1896, this gem of a bookstore moved to the sleepy little seaside village in Southern California in the 1930s and is the oldest continuously family-owned and operated bookstore in the United States. Surrounded by a now bustling tourist mecca, Warwick's radiates the sense of a true community marketplace from its Girard Avenue location and is now run by W. T.'s great-granddaughter, Nancy Warwick.

Warwick's knew the secret to success was to become not just a destination, but instead, an integral part of the community. Generations of locals have brought their kids in for story time, picked up school supplies, or ordered

Gibbs M. Smith, *Warwick's,* 2009. Oil on linen, 16" × 20".

personalized wedding invitations. Both patrons and their dogs are known on a first-name basis as they pass through on their weekly rounds about the village. Every pooch makes a beeline for the counters where the treats are kept.

In addition to books and office supplies, Warwick's has earned a name for its carefully curated gift offerings that include fair trade items from around the world. Whether it's personalized stationery, unique hand-crafted jewelry, or eclectic artisan crafts, Warwick's has grown to be one of the area's most distinctive shopping experiences.

Well known to the publishing industry, Warwick's has hosted presidents and prime ministers as well as authors and artists. Its knowledgeable book staff has a knack for introducing readers to the brightest writers before they became bestsellers or prize winners. Some of today's most well-known authors request that the village of La Jolla be added to book tours that include New York City, Chicago, and Los Angeles. The Warwick's event calendar is always full of exciting debut authors as well as international favorites.

Warwick's continues to expand its literary influence by participating in the La Jolla Reads, One Book, One San Diego, and San Diego Festival of Books programs. They partner with literacy and school fundraising events to give back to the reading community. Its Weekends with Locals program spotlights area authors and allows them to reach out to an eager reading community.

In a world overwhelmed with impersonal online choices, Warwick's is a proud part of a growing independent bookstore movement that believes in the magic of the printed page in your hands.

Gibbs M. Smith, *Sam Weller's Bookstore in the Rain,* 1996. Oil on linen, 16" × 20".

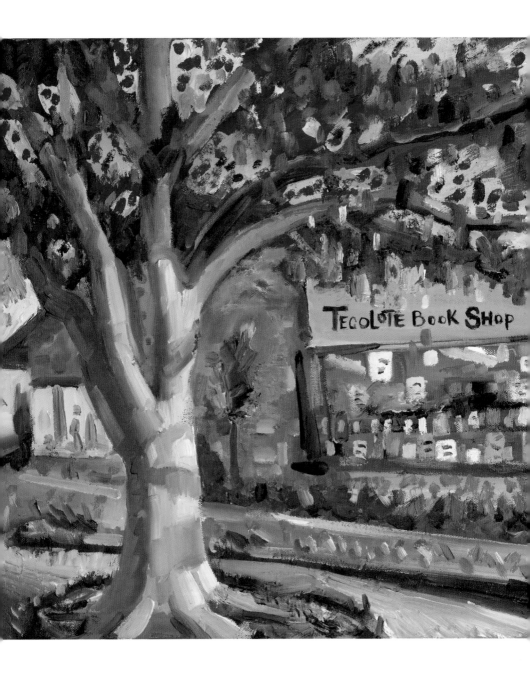

Tecolote Book Shop

Santa Barbara, California

Opened in 1925 in the Montecito area of Santa Barbara, the beloved Tecolote Book Shop was in danger of closing in 2007 after eighty-two years in business. But Mary Sheldon, the manager at the time, knew how important the independent store was to the community and wanted to do everything she could to help save it. She found three willing partners, Len Freedman, Marc Winkelman, and longtime customer Herb Simon, to help her purchase the shop from then-owner Peggy Dent. Mary was able to save this local treasure, and the community proudly supports it by shopping there as their parents and grandparents did.

Mary and her two employees are exceptionally knowledgeable about books and are happy to make recommendations or locate elusive out-of-print titles.

Gibbs M. Smith, *Santa Barbara in the Spring,* 2009.
Oil on linen, 16" × 20".

Books & Co.

New York, New York

Founded in 1978 by Jeanette Watson, this two-level, brick-walled, wood-shelved store was best known for fostering great writers and for its intelligent, diverse collection of hard-to-find books on philosophy, poetry, classic literature, and art, as well as popular bestsellers. Locals and celebrities alike treasured it for its atmosphere of sophistication and literary cachet. Eminent writers and playwrights (Jacques Derrida, Susan Sontag, Kurt Vonnegut, Truman Capote, Neil Simon, and Sam Shepard, to name a few) gave readings there or shopped there or both, and famous actors and musicians also browsed the shelves. "The Wall," covered in thoughtfully selected works, was a veritable Who's Who of literature.

Books & Co. closed in 1997 amid great protests from writers and loyal customers.

Gibbs M. Smith, *Jeanette's Bookstore, New York,* 1994. Oil on linen, 16" × 20".

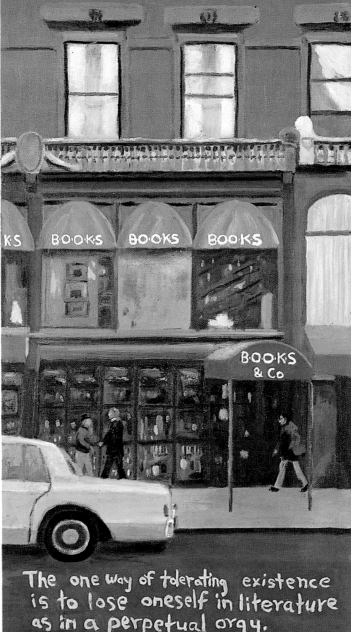

The one way of tolerating existence
is to lose oneself in literature
as in a perpetual orgy.
Gustave flaubert 1858

G.M.Smith

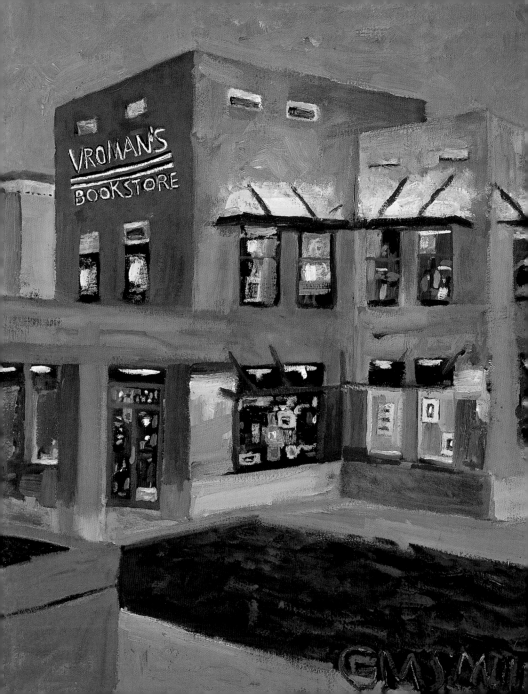

Vroman's Bookstore

Pasadena, California

—————•—————

Adam Clark Vroman, the well-known photographer who specialized in images of Native Americans and of the Southwest, founded Vroman's Bookstore in 1894. This makes Vroman's one of the oldest continuously operating independent bookstores in America. The store's long, rich history has included thousands of author signings, being named *Pasadena Weekly*'s Bookstore of the Year, eleven years running, and *Publisher Weekly*'s Bookseller of the Year, the industry's highest honor. Continuing Mr. Vroman's commitment to philanthropy, the store has had strong community ties, including a current program whereby the store donates proceeds of purchases to local charities.

Gibbs M. Smith, *Vroman's Bookstore,* 2003. Oil on linen, 16" × 20".

Broadway Books

Portland, Oregon

Founded in 1992 by Gloria Borg Olds and Roberta Dyer, Broadway Books is a great neighborhood bookstore located in northeast Portland. Strong collections of contemporary literary fiction, biography, and poetry—including many books by local authors—line the shelves, along with a good selection of regular best-selling titles.

Broadway Books is proud of its continued connection to the community it serves. The store hosts readings by both local and national touring authors and is involved in fundraising activities and literacy programs, supporting local writers and students.

Gibbs M. Smith, *Autumn Afternoon in Portland,* 2009. Oil on linen, 16" × 20".

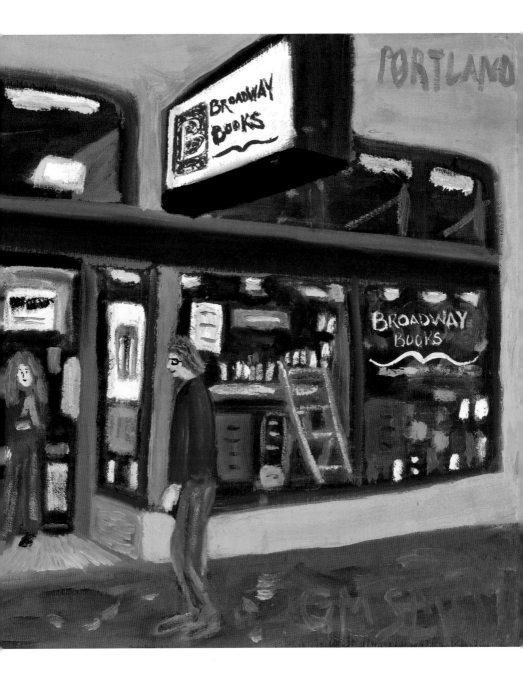

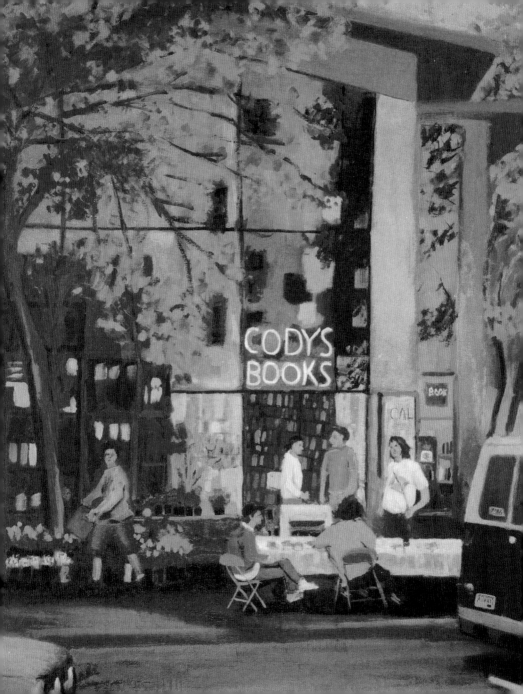

"All good books are alike in that they are truer than if they had really happened and after you are finished reading one you will feel that all that happened to you and afterwards it all belongs to you: the good and the bad, the ecstasy, the remorse and sorrow, the people and the places and how the weather was."

—Ernest Hemingway

Gibbs M. Smith, *Bookstore on Telegraph Avenue, Berkeley,* 1989. Oil on linen, 16" × 20".

D.G. Wills Books

La Jolla, California

La Jolla, California, an interesting combination of beachfront town and intellectual center, is home to the Salk Institute and the University of California, San Diego, as well as D.G. Wills. Founded by Dennis Wills in 1979, this fine independent bookstore has a loyal and intellectual clientele. Wills and his carpenter friends have created a marvelous interior—with a redwood beam cathedral ceiling—and exterior that have a distinct personality. Wills hosts hundreds of events each year in the store and has included readings from such writers as Allen Ginsberg, Norman Mailer, and Gore Vidal.

Dennis Wills characterized the feeling of the store as a "sort of nineteenth-century cracker barrel hardware store from a John Ford film, with Pabst Blue Ribbon in the refrigerator." The bookstore inventory is jam-packed from floor to ceiling with unique new and old books, with a special emphasis in classical studies, philosophy, and science.

Gibbs M. Smith, *La Jolla Bookstore*, 2006. Oil on linen, 16" × 20".

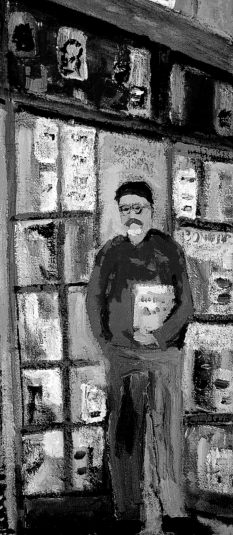

D.G.WILLS

La Jolla

CUBISM

STYLE

POETRY

SURF

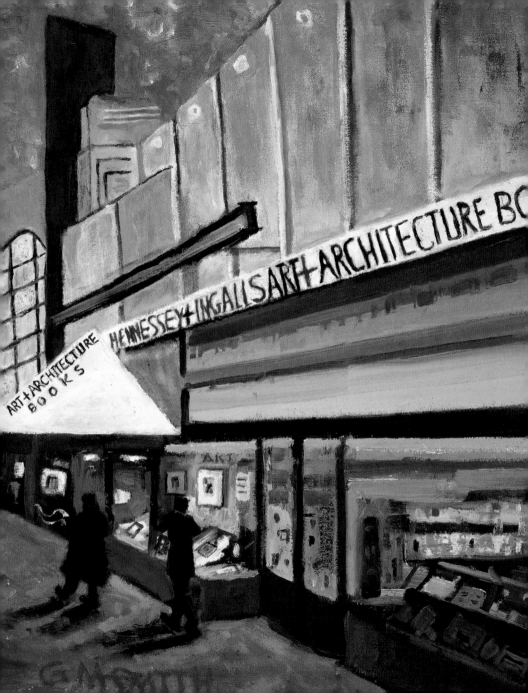

Hennessey + Ingalls

Los Angeles, California

———— • ————

Since its founding in 1963, Hennessey + Ingalls has grown to fill a unique niche in American retailing. They are the largest art, architecture, and design bookstore in the western United States, and possibly the largest retail operation in the country dealing solely with books on the visual arts. Founded by Reginald Hennessey as an outlet for rare and out-of-print architecture books, Hennessey + Ingalls is still family-owned and managed by Reginald's son, Mark Hennessey, and grandson Brett Hennessey.

Gibbs M. Smith, *Hennessey + Ingalls,* 2003. Oil on linen, 16" × 20".

Ken Sanders Rare Books

Salt Lake City, Utah

"In some manner or another, I have been involved in the world of books virtually all my life.

"From the beginning, the word was there, and I read it, revered it, and devoured it. Later, my childhood appetite for reading broadened into a desire to collect books, as well as read them. I also came to love them as physical objects—I began to appreciate their bindings and design, their illustrations and typography, as well as their content. I looked at them, fondled them, and inhaled them. If there was a God, his name was Biblio.

Gibbs M. Smith, *Ken Sanders Books,* 2005. Mixed media, 16" × 20".

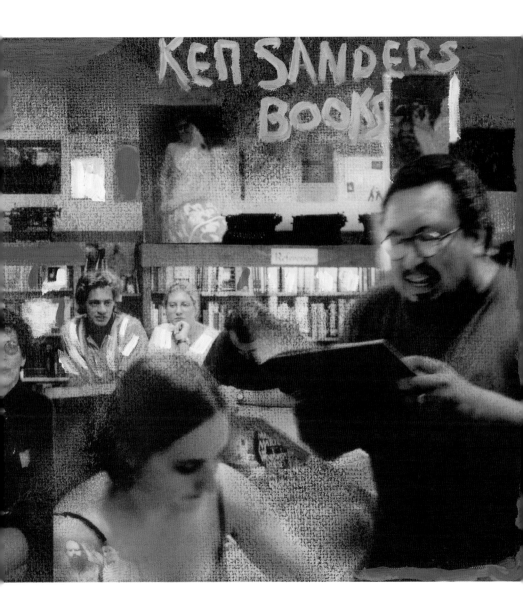

"In the last fifty years, my roles in the book world have included reader, collector, new bookseller, antiquarian book dealer, publisher, editor, occasional writer, and always champion of the printed word in all its myriad manifestations. In these early years of the twenty-first century, there has been an awful lot of talk about 'the death of the book.' What is being forgotten in this dialogue is that devotees of the book have always been on the margins of society—in modern society, booklovers are about as mainstream as druids. Whether two thousand years ago in the great lost library of Alexandria, half a millennium ago in Gutenberg's time, or at any time and place since human beings first articulated their thoughts on clay, stone, and papyrus, those of us involved in these matters have always lived in some far distant corner of the universe.

"There has been a great upheaval in information distribution in the last few decades that is accelerating as we speak. No one now living on the planet knows where it will end up. Google, Wikipedia, the World Wide Web, Kindle, ebooks, print on demand, and the next new thing threaten to extinguish the old-fashioned book. Perhaps. I think not: the transformation will continue. The value of books transcends the informational, and while some of us in the book world will become extinct, the rest of us will always be here, doing what we have always done: loving books, keeping Biblio alive in the world."

—Ken Sanders, owner of Ken Sanders Rare Books

Gibbs M. Smith, *Elliot Bay Book Co., Seattle,* 2006. Oil on linen, 16" × 20".

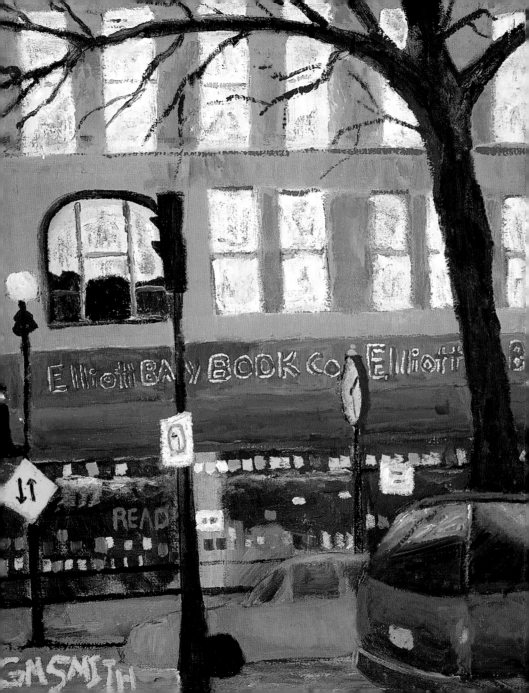

Madison Avenue Bookshop
New York, New York

Madison Avenue Bookshop was located in the heart of the Upper East Side's shopping area at 833 Madison Avenue. With its elegant, tailored façade, the shop long served its distinguished neighborhood.

The store was opened in 1973 by Arthur Lehman Loeb, who ended up giving the store and the building to Perry Haberman, a longtime employee who had become the store's manager. In 2003, Haberman made the difficult decision to close the store. Its many longtime customers felt the loss. Madison Avenue Bookshop was the kind of store where the salespeople knew you by name, would select titles specifically for you, and would order and hand deliver books to your residence. The Upper East Side lost a neighborhood treasure when Madison Avenue Bookshop closed its doors.

Gibbs M. Smith, *Madison Avenue Bookshop,* 2002. Oil on linen, 16″ × 20″.

BookPeople of Moscow
Moscow, Idaho

On November 17, 1973, new Moscow resident Ivar Nelson opened the door of his brand-new store BookPeople of Moscow at 512 S. Main Street. Ivar misplaced the key that first morning and was fifteen minutes late, much to the amusement of the line-up of customers who were waiting to browse in the new shop.

"Young man," one woman said, wagging a finger at Ivar, "This is no way to start a business."

Fortunately Moscow and the wider community on the Palouse River supported BookPeople despite that early mishap, allowing the store to celebrate its forty-fifth anniversary in November 2018. The store has been at its current location, 521 S. Main, across the street from its original home since 1999. The community rallied at that time to help the store move, forming a human chain across Main Street to pass the books along, one by one, to their new home.

Current managing owner, Carol Price, and her business partners purchased the store and completely remodeled its interior in January 2012, changing the stock from mostly used to mostly new books. Carol and her staff love their role in making Moscow a great place to live, hosting a variety of author events, community events, and children's programs throughout the year. BookPeople is the longest continually operating bookstore in the state of Idaho and it is proud and grateful to have reached this milestone.

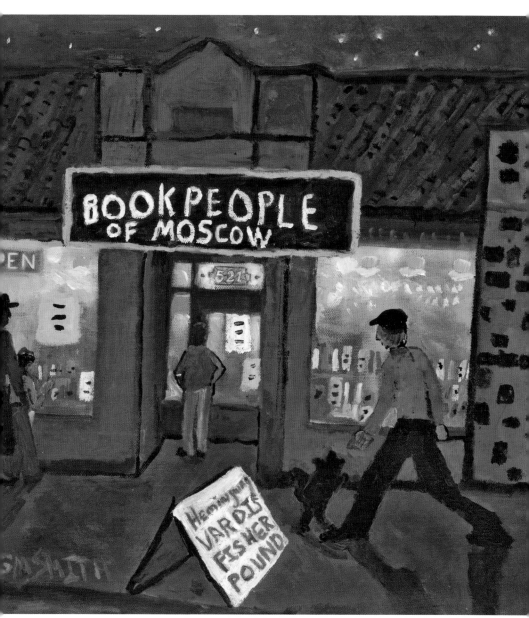

Gibbs M. Smith, *BookPeople of Moscow,* 2011. Oil on linen, 20" × 16".

Heywood Hill

London, England

One of America's most beloved bookshops is actually in London. Heywood Hill was founded in 1936 but it was the novelist Nancy Mitford, who worked there in the 1940s, who really put the shop on the map in a social sense. American officers on leave in London during World War II would stroll up to see her after lunch to gossip and buy books. The place has been a society bookshop for well-read Americans visiting London ever since.

Heywood Hill is now owned by Mitford's nephew, the Duke of Devonshire. Its strength has always been exceptional customer service delivered by booksellers who love good writing and really care about their clients. One customer in New York put his beloved on a flight from JFK and asked the shop to be there with a gift-wrapped book in the arrivals hall when she landed at Heathrow. Heywood Hill was happy to oblige.

This Mayfair shop may be small but it remains influential. To survive in the digital age it has developed niche services for readers and collectors including A Year in Books, its famous monthly book subscription service, which now has customers in over fifty countries and almost every American state. The shop also deals in rare books and sells formed collections privately. But the biggest chunk of the business is now the creation of themed libraries—reading sanctuaries—assembled around clients' interests. Subjects covered have included "Every Aviation and Escapee Memoir from WWII," "The Positive Story of Humanity: Across the Arts and the Sciences," and "The Great American Novel." Heywood Hill is enjoying its ninth decade in good health.

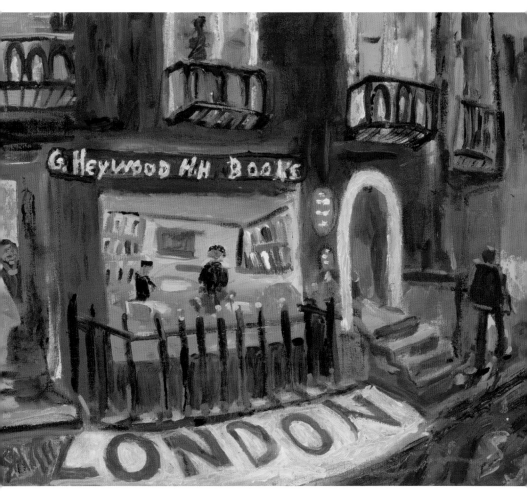

Gibbs M. Smith, *G. Hewood Hill,* 2015. Oil on linen, 20" × 16".

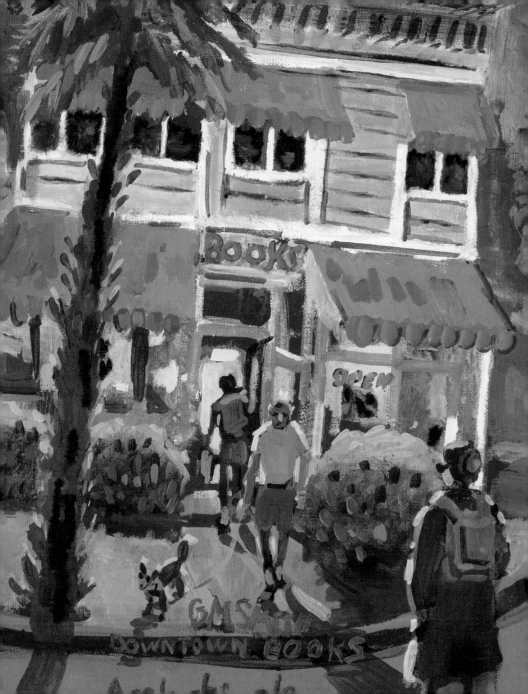

Downtown Books and Purl

Apalachicola, Florida

Built in 1900 after fire devastated Apalachicola's business district, this iconic wood-frame building has been a barber shop, a laundry, a wood-yard, an art gallery, and, since 2002, Downtown Books, serving locals and visitors to the historic Gulf Coast shipping port.

Gibbs M. Smith, *Downtown Books,* 2011. Oil on linen, 16" × 20".

Collected Works

Santa Fe, New Mexico

———•———

Collected Works Bookstore & Coffeehouse is the oldest independent bookstore in Santa Fe, presenting a wide selection of literature, poetry, local history, music, art, architecture, kids books, and travel. The store hosts frequent book signings, both inside the café and at community presentations across the city.

Gibbs M. Smith, *Summer Afternoon in Santa Fe,* 2009. Oil on linen, 16" × 20".

———

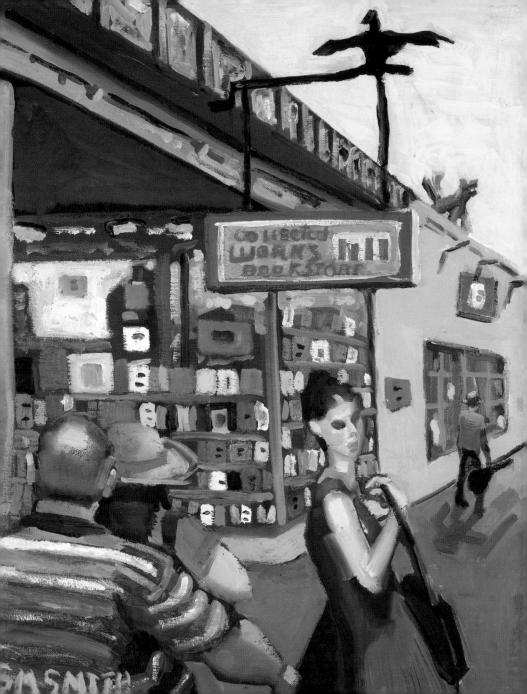

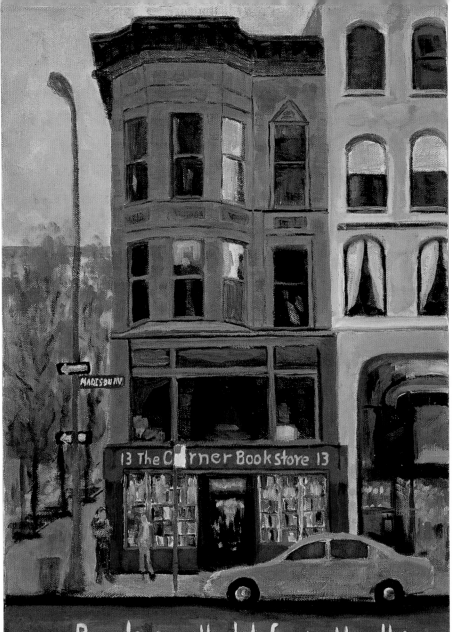

13 The Corner Bookstore 13

MADISON AV.

People say that life is the thing, but I Prefer reading

Logan Pearsall SMITH

GMSMITH

The Corner Bookstore
New York, New York

———— • ————

The Corner Bookstore, owned by Lenny Golay and Ray Sherman, is located on the Upper East Side of Manhattan and offers an extremely knowledge-able and friendly staff that is very involved with its customers. This tiny bookstore features an extensive children's collection as well as a wide vari-ety of other titles that includes classics, bestsellers, art, design, architec-ture, history, poetry, mysteries, cookbooks, and travel books.

Gibbs M. Smith, *Corner Bookstore, Upper East Side,* 1996. Oil on linen, 16″ × 20″.

Lenox Hill Bookstore

New York, New York

Located on upper Lexington Avenue in Manhattan, Lenox Hill Bookstore was owned by Lenny Golay and Ray Sherman, who own The Corner Bookstore on Madison Avenue. Before it closed in 2006, Lenox Hill Bookstore was known for its refined, sophisticated atmosphere. The titles were carefully chosen, and the store boasted an excellent children's section stocked with classics and the best of contemporary fiction. Their selection of art books was excellent.

The painting of this store was created in December 1996: Marcel Duchamp on an easel in front of the store, a solitary pedestrian walking by; a cold December evening, a warm and inviting bookstore.

Gibbs M. Smith, *Marcel Duchamp and Bookstore*, 1996. Oil on linen, 16" × 20".

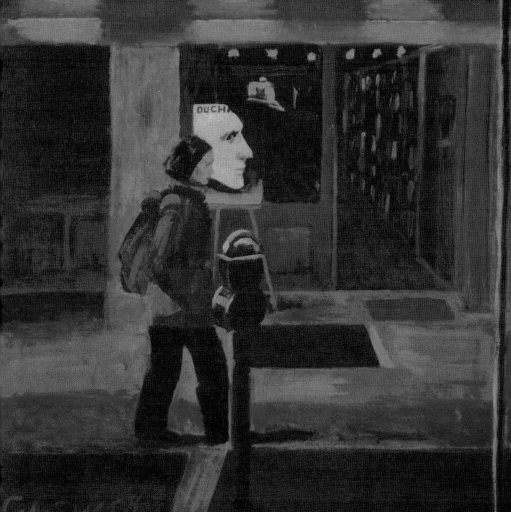

Page & Palette

Fairhope, Alabama

Located at 32 South Section Street, Page & Palette was founded in 1968 by Betty Joe Wolff and is a well-known enclave for artists and writers. The store sells books as well as art supplies, and it has a charming coffee shop called Latte Da, which sells Southern favorite Blue Bell ice cream along with lattes and cappuccinos. An added bar and event space called The Book Cellar creates a fun environment to host visiting authors.

Today the store is owned by Betty Joe's granddaughter, Karin Wilson, and Karin's husband, Kiefer. In addition to adding Latte Da, The Book Cellar, and a wonderful children's section to the store, Karin and Kiefer have established the Page & Palette Foundation, which does great things for their community. Page & Palette marks its fiftieth anniversary in 2018.

Gibbs M. Smith, *Alabama Bookstore*, 2007. Oil on linen, 16" × 20".

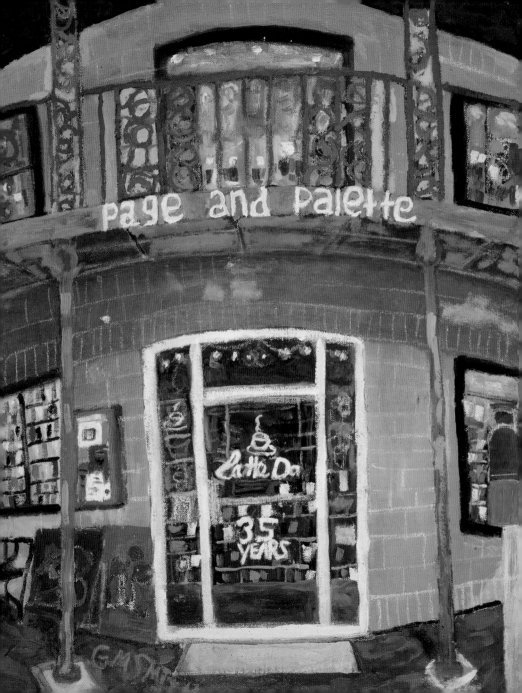

Skylight Books

Los Angeles, California

———————— • ————————

Established in 1996, Skylight Books carries on the tradition of bookselling in a 1930s-era warehouse building of bricks and lumber that has been a bookstore since the early 1970s. (The first bookstore in this location, Chatterton's, went dark in 1994.) Right in the heart of Los Feliz, a lively neighborhood of restaurants, trinket traders, cafés, second-hand clothing stores, crafty co-op shops, theaters, and bars, the community is east of Hollywood and west of Silver Lake, Echo Park, and Downtown. With high-beamed ceilings and bright skylights that encourage a large ficus tree to grow in its center, the bookstore focuses on contemporary and classic literature, current events, and social justice while also having healthy selections of philosophy, children's books, regional history, and cookbooks. In 2008 Skylight Books opened an Arts Annex two doors down. The space houses an inspiring collection of books on photography, architecture, film, art, music, design, plays, fashion, and graphic novels.

They host more than two hundred events a year (almost all free and open to the public) featuring authors and icons such as John Rechy, Patti Smith, Junot Diaz, Daniel Clowes, Roxane Gay, Amy Goodman, Jeanette Winterson, Paul Beatty, Viet Thanh Nguyen, and many more. With

Gibbs M. Smith, *Los Feliz, Los Angeles,* 2009. Oil on linen, 16" × 20".

———

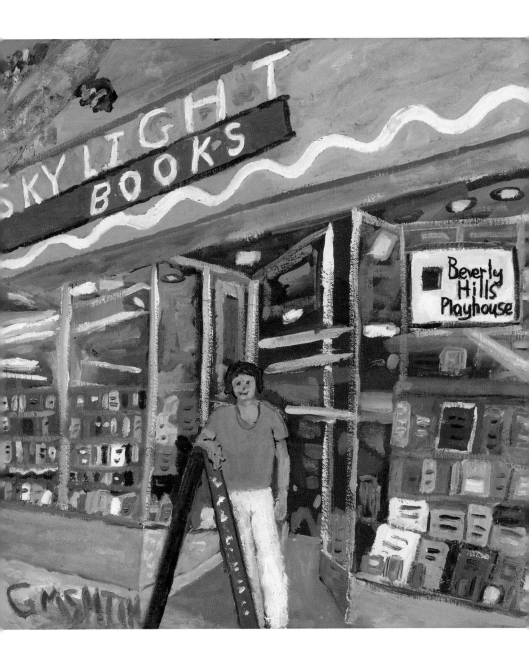

community partners like PEN and the *Los Angeles Times,* the store co-hosts larger author events for celebrities such as Elizabeth Warren, Zadie Smith, and Johnny Marr.

Skylight Books strives to be an integral part of their local neighborhood, the great city of Los Angeles, and the bookselling community at large, while championing the ideas of literacy, art, and freedom of expression.

Gibbs M. Smith, *That Bookstore in Blytheville,* 2007. Oil on linen, 16" × 20".

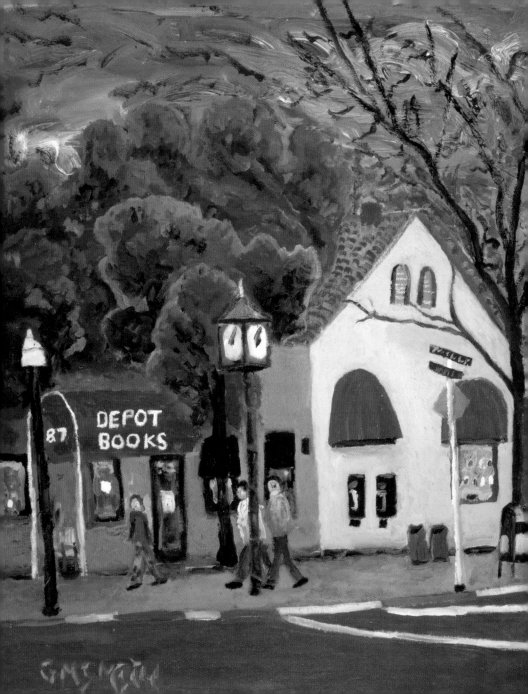

The Depot Bookstore & Café
Mill Valley, California

———— · ————

Family owned and operated, the Depot Bookstore was founded by William and Mary Turnbull in 1987 and is located in a historic railway depot built in 1925 for the Northwest Pacific Railroad. It is a wonderful full-service bookstore that has become a major cultural institution with enthusiastic community support. The café is a favorite local hangout, where you can sip a latte on the patio while reading the latest bestseller or watching people on the town square. Each month the café features works of a local artist on its walls.

Gibbs M. Smith, *Mill Valley Bookstore*, 2007. Oil on linen, 16" × 20".

The Cottage Book Shop
Glen Arbor, Michigan

"Being an independent bookstore owner has got to be the world's best job. Where else can you choose books whose stories and ideas you love and wish to personally share with enthusiastic, literate friends—friends we have come to make with authors and customers, who call us their favorite bookstore? In my case, it has also been fun to create a gathering place in a historic log cabin near a scenic national lakeshore that annually hosts a million seasonal visitors. I chose to move this resort log cabin into the center of the village to match the bookstore name, carry local history books displayed in a canoe, and showcase design books on rustic cedar shelves to create a special sense of place. What's not to love about bookselling?"

—Barbara Siepker, owner of The Cottage Book Shop

Gibbs M. Smith, *On the Shore of Lake Michigan,* 2002. Oil on linen, 16" × 20".

THE COTTAGE BOOK SHOP

G M SMITH

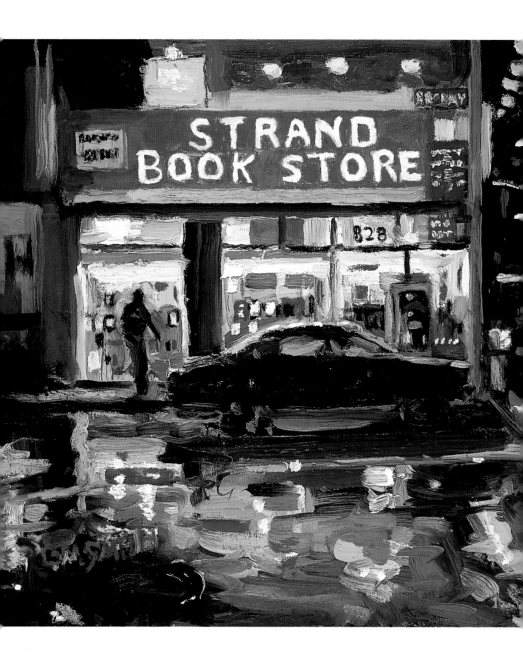

Strand Book Store

New York, New York

———◆·◆———

A visit to Strand is one of the greatest bookstore experiences our nation affords. Strand was founded by Benjamin Bass in 1927 and was operated by his son Fred Bass for more than sixty years, until his retirement in 2017. Fred began working in the store at the age of thirteen and took over as manager in 1956. A few years later, he moved the store from its original location on New York's "Book Row"—located on Fourth Avenue and once home to forty-eight bookstores—to its current location on Broadway and 12th Street.

Today Strand, operated by Fred's daughter Nancy Bass Wyden, is the only survivor of Book Row. The store continues to thrive, thanks in part to its huge inventory. Strand is home to literally millions of books—offering thousands of new titles at a discount—and has an impressive collection of used books, hard to find art books, and the largest collection of rare books in New York. Strand also hosts nightly literary events and sells locally designed bookish gifts and apparel. One could spend days there, searching for that great find or stumbling upon it while merely browsing. You never know what a visit to Strand will turn up.

Gibbs M. Smith, *Strand Book Store in the Rain,* 2003. Oil on linen, 16" × 16".

Sherman's of Bar Harbor

Bar Harbor, Maine

Bill Sherman opened his shop in Bar Harbor back in 1886, making Sherman's the oldest bookstore in Maine, and one of the oldest in the country. In the beginning the store included a printing press used to print local books and stationery. First Bill, then his daughters, ran the bookstore until 1962 when the Sherman sisters sold it to Pat and Mike Curtis. Under three generations of the Curtis family, Sherman's has expanded and grown to become a Bar Harbor landmark.

Gibbs M. Smith, *Sherman's Books and Stationery,* 2009. Oil on linen, 20" × 16".

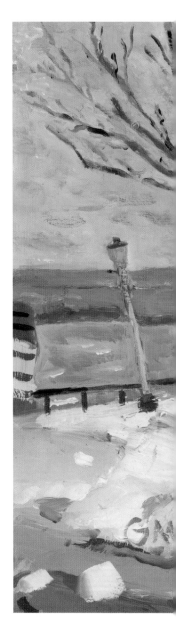

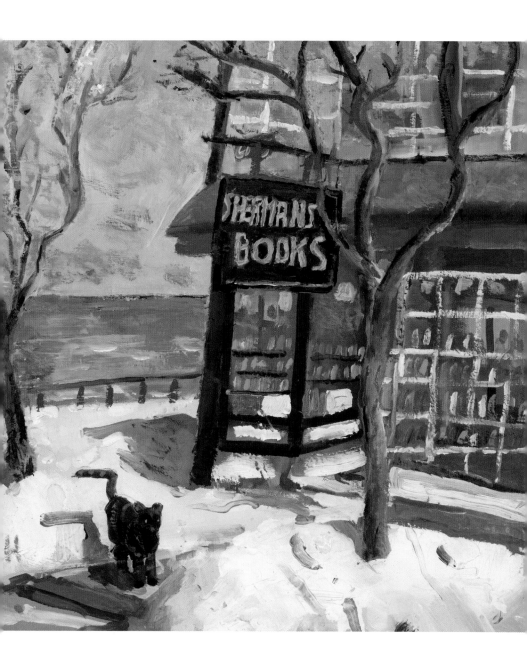

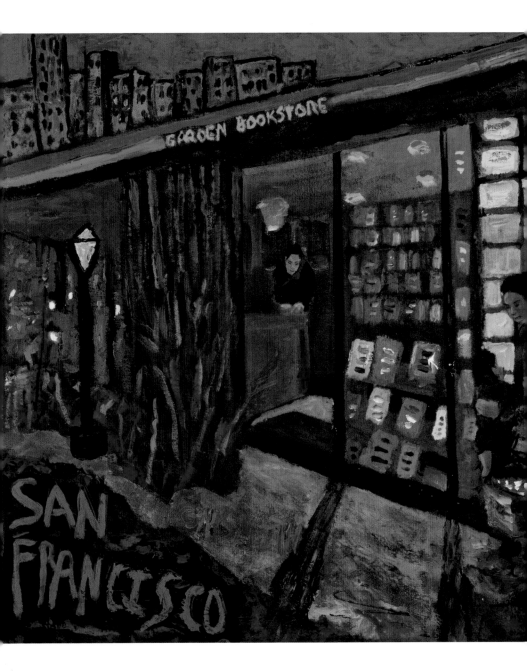

The Garden Bookstore
San Francisco, California

Originally an information kiosk, this tiny, charming, gem of a store carries unique garden gifts and a wide range of books on botany, horticulture, birding, nature writing, local history, hiking, biking, and children's titles. A small arbor also stocks plants from the garden's own nursery and features everything from California natives to rare and alluring cloud forest plants. The store welcomes garden enthusiasts from around the world and has long served as the starting point for docent-led school tours attended by thousands of children each year.

"If you have a garden and a library,
you have everything you need."

—Cicero

Gibbs M. Smith, *Garden Bookstore*, 2011. Oil on linen, 20" × 16".

Bookstores I Have Visited

El Ateneo Grand Splendid
Av. Santa Fe 1860
Buenos Aires,
Argentina
54.11.4813.6052
yenny-elateneo.com

I visited on
__ / __ / ____

Bank Street Bookstore
2780 Broadway (at
West 107th)
New York, NY
10025
212.678.1654
bankstreetbooks
.com

I visited on
__ / __ / ____

Barnes & Noble
33 East 17th St.
New York, NY
10003
212.253.0810
barnesandnoble
.com for more
locations

I visited on
__ / __ / ____

Blue Hill Books
26 Pleasant St.
Blue Hill, ME
04614
207.374.5632
bluehillbooks.com

I visited on
__ / __ / ____

BookPeople of Moscow
521 S. Main
Moscow, ID 83843
208.882.2669
bookpeopleof
moscow.com

I visited on
__ / __ / ____

Book Soup
8818 Sunset Blvd.
West Hollywood,
CA 90069
310.659.3110
booksoup.com

I visited on
__ / __ / ____

Books & Books
265 Aragon Ave.
Coral Gables, FL
33134
305.442.4408
booksandbooks.com

I visited on
__ / __ / ____

Broadway Books
1714 NE Broadway
Portland, OR 97232
503.284.1726
broadwaybooks.net

I visited on
__ / __ / ____

Builders Booksource
1817 Fourth St.
Berkeley, CA 94710
800.843.2028
buildersbooksource
.com

I visited on
__ / __ / ____

Changing Hands
6428 S. McClintock
Dr.
Tempe, AZ 85283
480.730.0205
changinghands.com

I visited on
__ / __ / ____

Chaucer's Bookstore
3321 State St.
Santa Barbara, CA
93105
805.682.6787
chaucersbooks.com

I visited on
__ / __ / ____

Christopher's Books
1400 18th St. (at
Missouri)
San Francisco, CA
94107
415.255.8802
christophersbooks
.com

I visited on
__ / __ / ____

City Lights Books
261 Columbus Ave.
San Francisco, CA
94133
415.362.8193
citylights.com

I visited on
__ / __ / ____

Collected Works
202 Galisteo St.
Santa Fe, NM 87501
505.988.4226
collectedworks
bookstore.com

I visited on
__ / __ / ____

The Corner Bookstore
1313 Madison Ave.
(at East 93rd St.)
New York City, NY
10128
212.831.3554
cornerbookstorenyc
.com

I visited on
__ / __ / ____

The Cottage Book Shop
5989 Lake St.
Glen Arbor, MI
49636
231.334.4223
cottagebooks.com

I visited on
__ / __ / ____

The Depot Bookstore & Café
87 Throckmorton
Ave.
Mill Valley, CA
94941
415.383.2665
depotbookstore.com

I visited on
__ / __ / ____

D.G. Wills Books
7461 Girard Ave.
La Jolla, CA 92037
858.456.1800
dgwillsbooks.com

I visited on
__ / __ / ____

Downtown Books and Purl
67 Commerce St.
Apalachicola, FL
32320
850.653.1290
downtownbooks
andpurl.com

I visited on
__ / __ / ____

The Elliott Bay Book
Company
1521 Tenth Ave.
Seattle, WA 98122
800.962.5311
elliottbaybook.com

I visited on
__ / __ / ____

Garcia Street Books
376 Garcia St. B
Santa Fe, NM 87501
505.986.0151
garciastreetbooks
.com

I visited on
__ / __ / ____

Garden Bookstore
San Francisco
Botanical Garden
Golden Gate Park
1199 9th Ave.
San Francisco, CA
94122
415.661.1316 x409
sfbotanicalgarden
.org

I visited on
__ / __ / ____

George Bayntun
Manvers St.
Bath, BA1 1jW, UK
44 (0) 1225 466000
georgebayntun.com

I visited on
__ / __ / ____

Green Apple Books
506 Clement St.
San Francisco, CA
94118
415.387.2272
greenapplebooks
.com

I visited on
__ / __ / ____

Hennessey + Ingalls
300 S. Santa Fe.
Ave. M
Los Angeles, CA
90013
213.437.2130
hennesseyingalls
.com

I visited on
__ / __ / ____

Heywood Hill
10 Curzon St.
London, WIJ 5HH
44 (0)20 7629 0647
heywooodhill.com

I visited on
__ / __ / ____

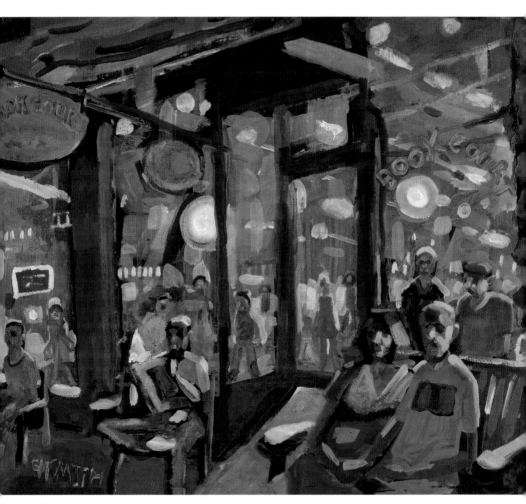

Gibbs M. Smith, *BookCourt*, *Brooklyn, New York,* 2010. Oil on linen, 20" × 16".

Joseph-Beth Booksellers
161 Lexington
Green Cir.
Lexington, KY
40503
859.273.2911
josephbeth.com

I visited on
__ / __ / ____

Ken Sanders Rare Books
268 S. 200 E.
Salt Lake City, UT
84111
801.521.3819
kensandersbooks
.com

I visited on
__ / __ / ____

Kepler's Books
1010 El Camino
Real
Menlo Park, CA
94025
650.324.4321
keplers.com

I visited on
__ / __ / ____

The King's English
1511 S. 1500 E.
Salt Lake City, UT
84105
801.484.9100
kingsenglish.com

I visited on
__ / __ / ____

Kramerbooks &
Afterwords
1517 Connecticut
Ave. NW
Washington, D.C.
20036
202.387.1400
kramers.com

I visited on
__ / __ / ____

Maria's Bookshop
960 Main Ave.
Durango, CO 81301
970.247.1438
mariasbookshop
.com

I visited on
__ / __ / ____

Mrs. Dalloway's Literary &
Garden Arts
2904 College Ave.
Berkeley, CA 94705
510.704.8222
mrsdalloways.com

I visited on
__ / __ / ____

Page and Palette
32 South Section St.
Fairhope, AL 36532
251.928.5295
pageandpalette.com

I visited on
__ / __ / ____

Parnassus Books
3900 Hillsboro Pike
Suite 14
Nashville, TN 37215
615.953.2243
parnassusbooks.net

I visited on
__ / __ / ____

Politics and Prose
 Bookstore
 5015 Connecticut
 Ave., NW
 Washington, D.C.
 20008
 202.364.1919
 politics-prose.com

 I visited on
 __/__/____

Powell's Books
 1005 W. Burnside
 St.
 Portland, OR 97209
 800.878.7323
 powells.com

 I visited on
 __/__/____

Prairie Lights Books
 15 S. Dubuque St.
 Iowa City, IA 52240
 319.337.2681
 prairielights.com

 I visited on
 __/__/____

Riverow Bookshop
 187 Front St.
 Owego, NY 13827
 607.687.4094

 I visited on
 __/__/____

R.J. Julia Independent
 Booksellers
 768 Boston Post Rd.
 Madison, CT 06443
 203.245.3959
 rjjulia.com

 I visited on
 __/__/____

Rizzoli
 1133 Broadway
 New York, NY 10010
 212.759.2424
 rizzolibookstore.com

 I visited on
 __/__/____

Weller Book Works
 607 Trolley Sq.
 Salt Lake City, UT
 84102
 801.328.2586
 wellerbookworks
 .com

 I visited on
 __/__/____

Shakespeare & Co.
 939 Lexington Ave.
 New York, NY
 10065
 212.772.3400
 shakeandco.com

 I visited on
 __/__/____

Shakespeare & Co.
 37 Rue de la
 Bûcherie
 75005 Paris, France
 00 33 (0) 1 43 25
 40 93
 shakespeareand
 company.com

 I visited on
 __/__/____

Sherman's of Bar Harbor
 56 Main St.
 Bar Harbor, ME
 04609
 207.288.3161
 shermans.com

 I visited on
 __ / __ / ____

Strand Book Store
 828 Broadway
 (at 12th St.)
 New York, NY
 10003
 212.473.1452
 strandbooks.com

 I visited on
 __ / __ / ____

That Bookstore in
 Blytheville
 316 W. Main
 Blytheville, AR
 72315
 870.763.3333
 tbib.com

 I visited on
 __ / __ / ____

Skylight Books
 1818 N. Vermont
 Ave.
 Los Angeles, CA
 90027
 323.660.1175
 skylightbooks.com

 I visited on
 __ / __ / ____

Tattered Cover Book Store
 1628 16th St.
 Denver, CO 80202
 303.436.1070
 tatteredcover.com

 I visited on
 __ / __ / ____

Three Lives & Company
 154 West 10th St.
 New York, NY 10014
 212.741.2069
 threelives.com

 I visited on
 __ / __ / ____

Square Books
 160 Courthouse Sq.
 Oxford, MS 38655
 662.236.2262
 squarebooks.com

 I visited on
 __ / __ / ____

Tecolote Book Shop
 1470 E. Valley Rd.
 Santa Barbara, CA
 93108
 805.969.4977
 tecolotebookshop
 .com

 I visited on
 __ / __ / ____

Village Books
 1200 Eleventh St.
 Bellingham, WA
 98225
 360.671.2626
 villagebooks.com

 I visited on
 __ / __ / ____

Vroman's Bookstore
 695 E. Colorado
 Blvd.
 Pasadena, CA 91101
 626.449.5320
 vromansbookstore
 .com

I visited on
 __ / __ / ____

Warwick's
 7812 Girard Ave.
 La Jolla, CA 92037
 858.454.0347
 warwicks.com

I visited on
 __ / __ / ____

Watermark Books & Café
 4701 East Douglas
 Wichita, KS 67218
 316.682.1181
 watermarkbooks
 .com

I visited on
 __ / __ / ____

Gibbs M. Smith, *Manhattan in the Rain, View from Central Park*, 1991. Oil on linen, 24" x 30"

Books I Have Purchased

Titles	Location	Date

Books I Have Purchased

Titles	Location	Date

Books I Have Purchased

Titles	Location	Date

Index

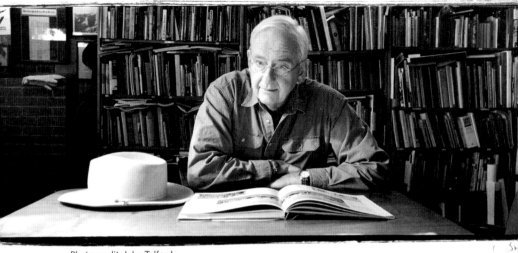

Photo credit: John Telford

Gibbs Smith, founder of his eponymous book publishing company, started the business in 1969 with his wife, Catherine, in Santa Barbara, California. After three years, they moved the company to Layton, Utah. Gibbs served as president, committed to the daily operations of the business for forty-eight years, until his death in 2017. This book is a celebration of Gibbs' legacy, the local bookstores that he loved, and fifty years of Gibbs Smith as an independent publisher.